CRUISING
WITH TUGGY

STORIES AND PHOTOGRAPHS

BY PETER FROMM

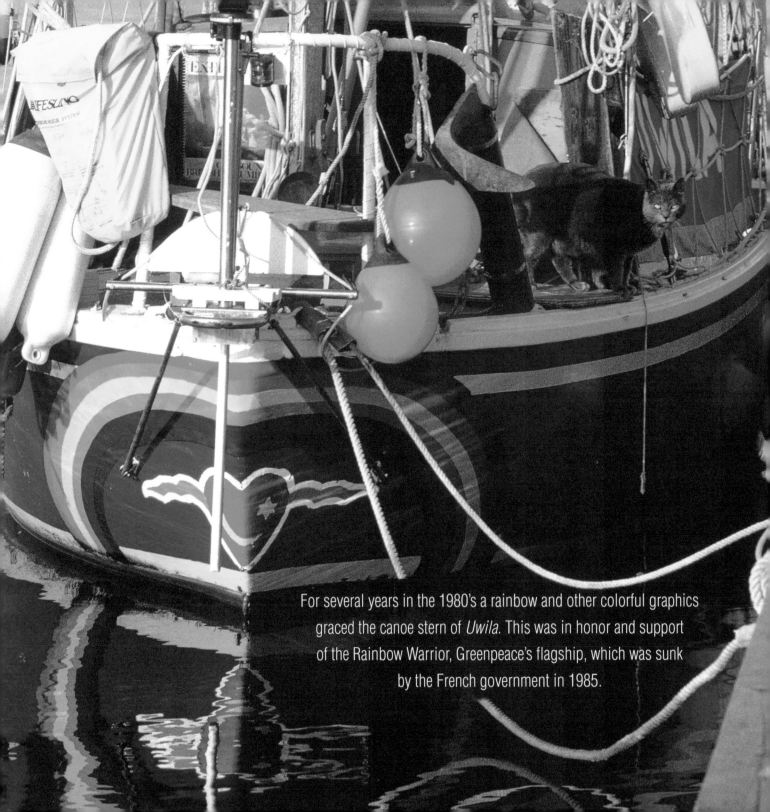

For several years in the 1980's a rainbow and other colorful graphics graced the canoe stern of *Uwila*. This was in honor and support of the Rainbow Warrior, Greenpeace's flagship, which was sunk by the French government in 1985.

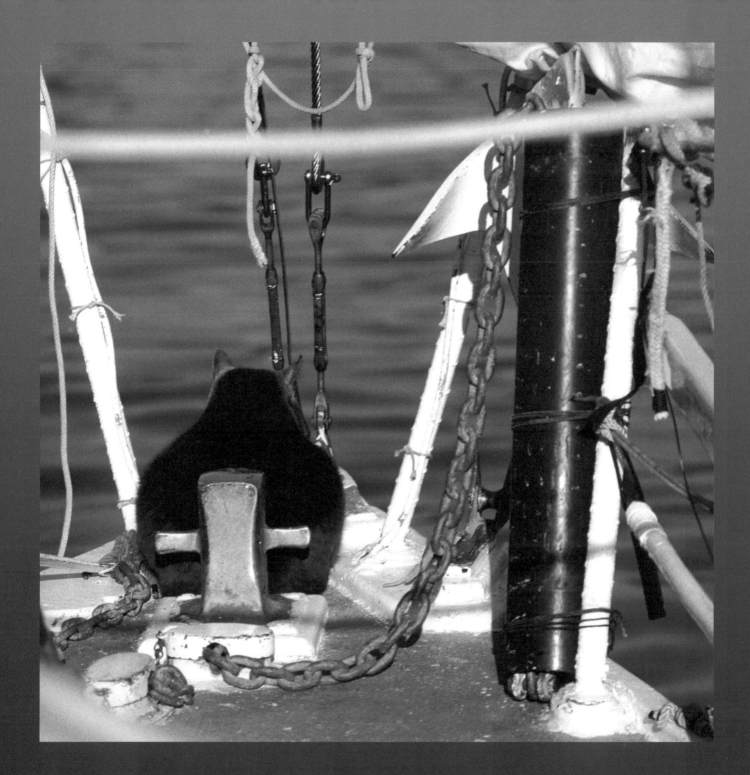

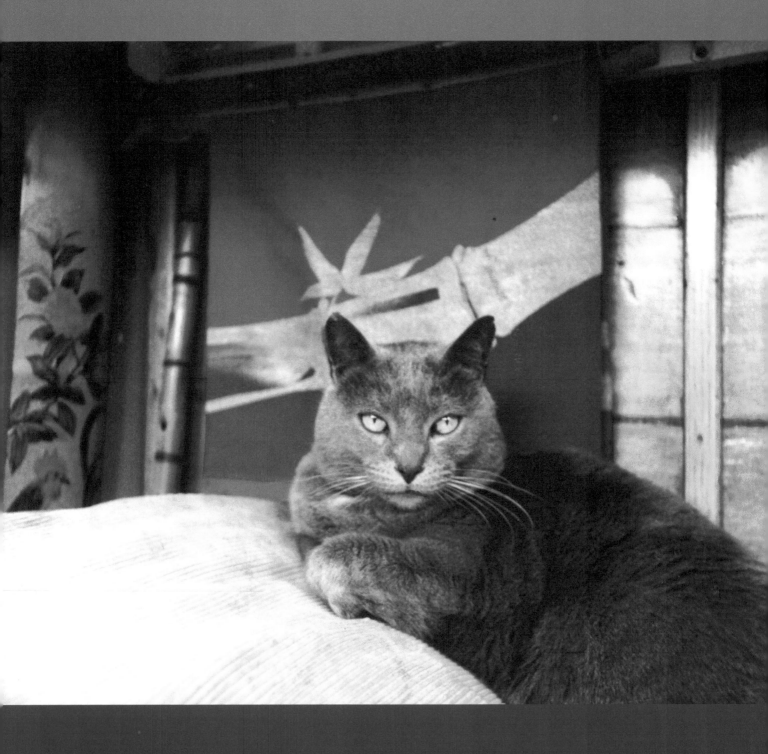

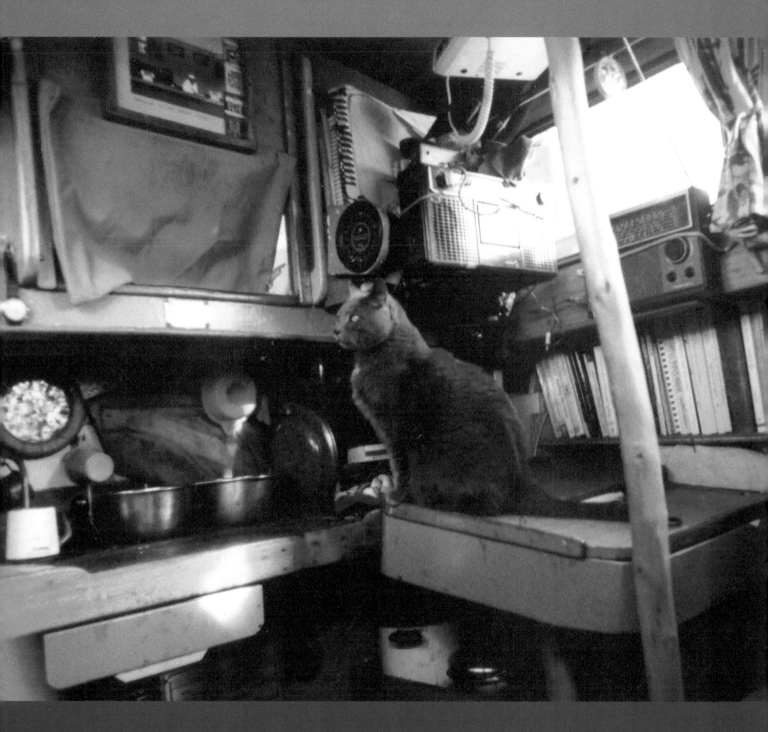

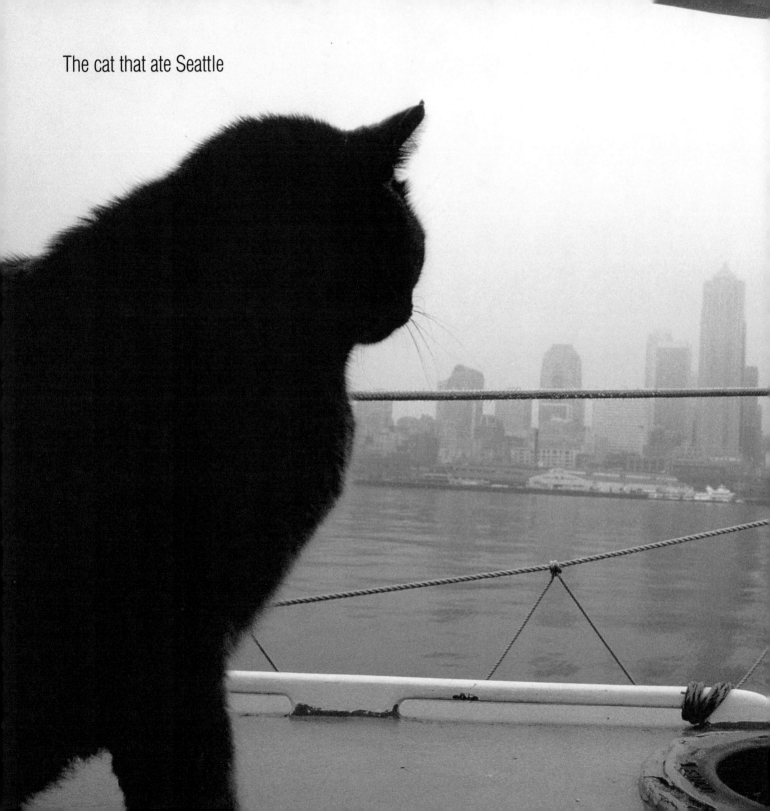

The cat that ate Seattle

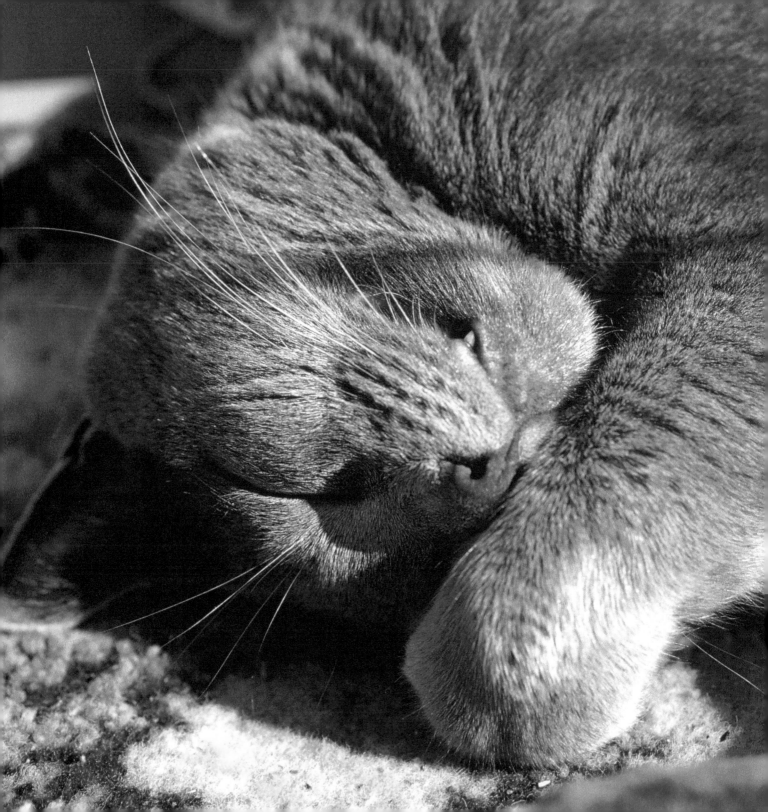

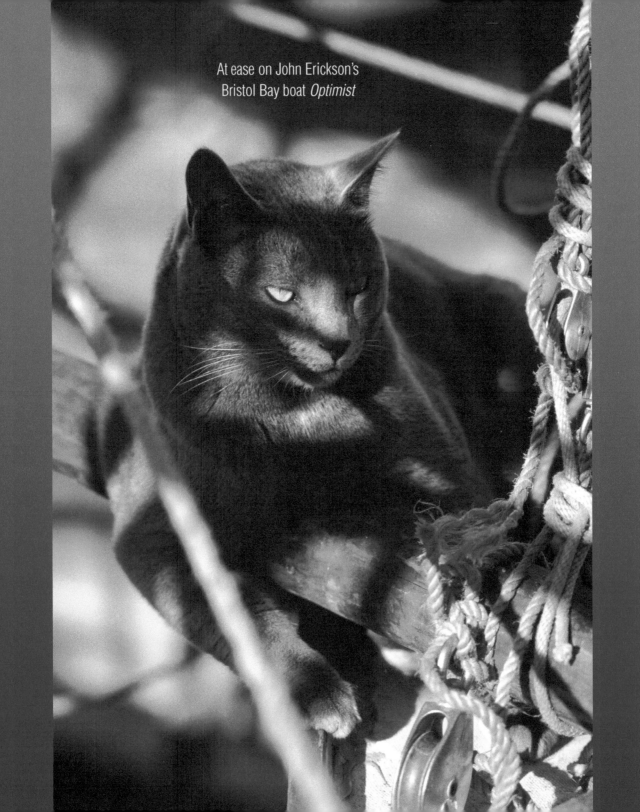

At ease on John Erickson's
Bristol Bay boat *Optimist*

CRUISING WITH TUGGY

STORIES AND PHOTOGRAPHS

BY PETER FROMM

WHALE TALES PRESS

FRIDAY HARBOR • WASHINGTON, USA

Cruising With Tuggy

by Peter Fromm

First Edition - IngramSpark
Copyright ©2021 by Peter Fromm

softcover: ISBN: 978-0-9648704-3-7
Book design, cover and layout by W. Bruce Conway

Library of Congress PCN pending

Lyrics from SPILL THE WINE - Eric Burden and War
(Papa Dee Allen / Harold Brown / B. B. Dickerson /
Lonnie Jordan / Charles Miller / Lee Oskar / Howard Scott)

Prints of the photos in this book may be ordered from the publisher.

Whale Tales Press
P. O. Box 13, Friday Harbor, WA 98250

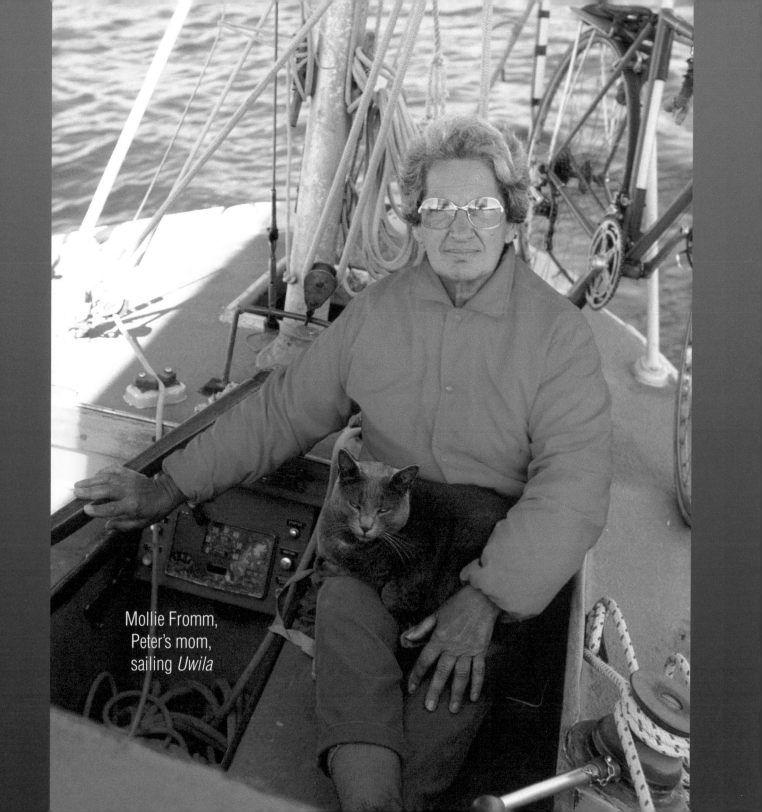

Mollie Fromm,
Peter's mom,
sailing *Uwila*

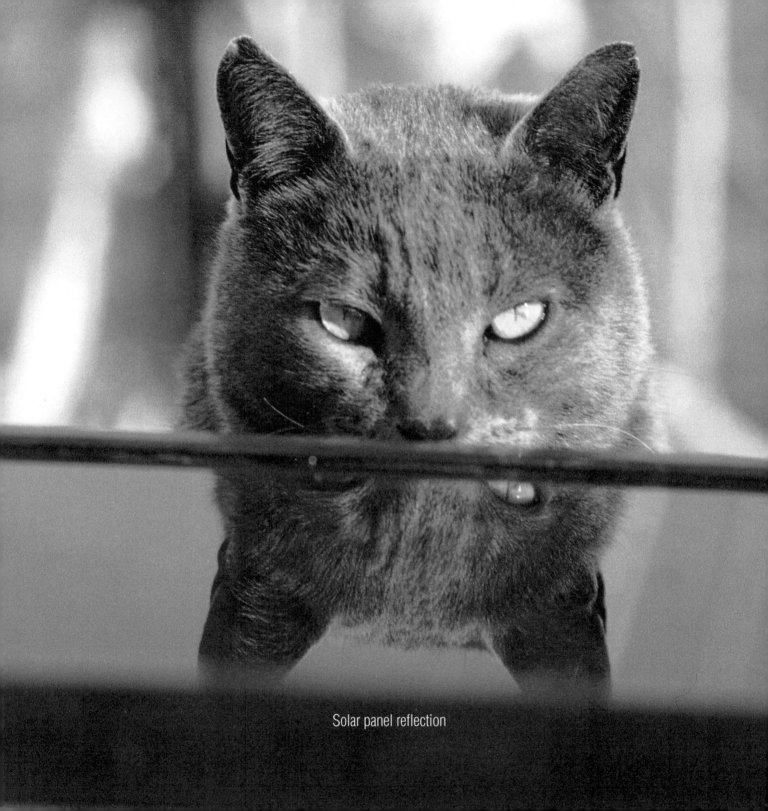

Solar panel reflection

Cruising With Tuggy
Table of Contents

Preface;
> in which I get a very big surprise,
> and a dream comes true.. 19

The Difference Between a Sea Story and a Fairy Tale23

Introduction;
> in which Tuggy's ship comes in,
> and *Uwila* and I get a cat ... 25

Our First Voyage;
> in which we sail home to the islands,
> and learn about living together. ... 31

The Mouse At Matia;
> in which Tuggy's guest gets fed ...47

Tuggy Falls Overboard;
> in which Tuggy gets a surprise,
> and I learn a lesson .. 53

Tuggy Swims Home;
> in which I get a surprise,
> and Tuggy learns a new skill ... 57

Dogs;
> in which Tuggy learns that some life forms are friendly,
> and some are not .. 61

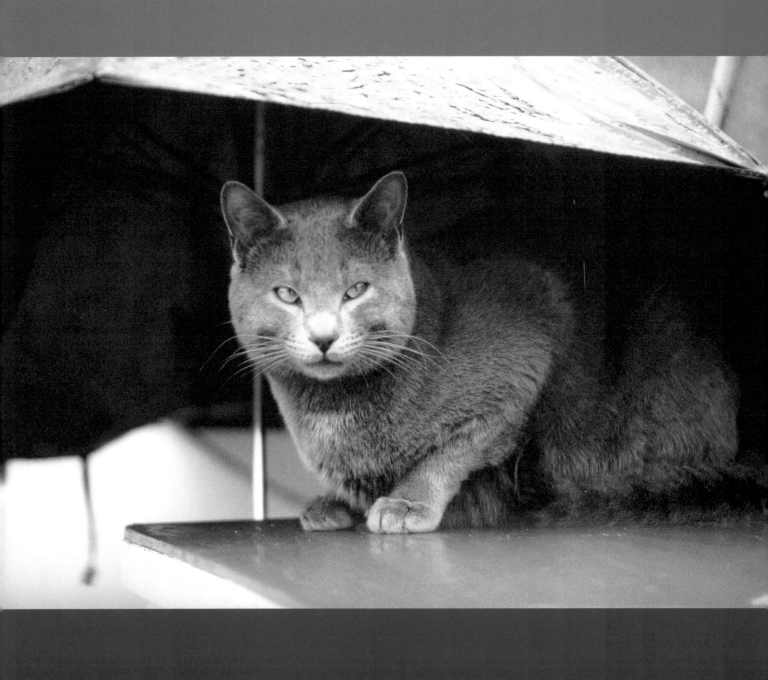

Tuggy Has a Worm;
in which Tuggy has something of value to a vet,
and it saves me some money ...67

Tuggy Sees the Whales;
in which huge animals swim close by *Uwila*,
and Mr. Cat puts himself in a very unlikely spot73

Clothes Pins;
in which Tuggy accepts appearing unusual,
so people can feel joy ...81

Vancouver Island;
in which we sail aboard another boat,
ate well and had adventures ...85

The Alternate Universe;
in which Tuggy goes some place else,
and is photographed there...91

The Legend of the Puget Sound Panther;
in which we meet a most fascinating person,
and learn something really cool ...95

Acknowledgements ...125

About the Author ..127

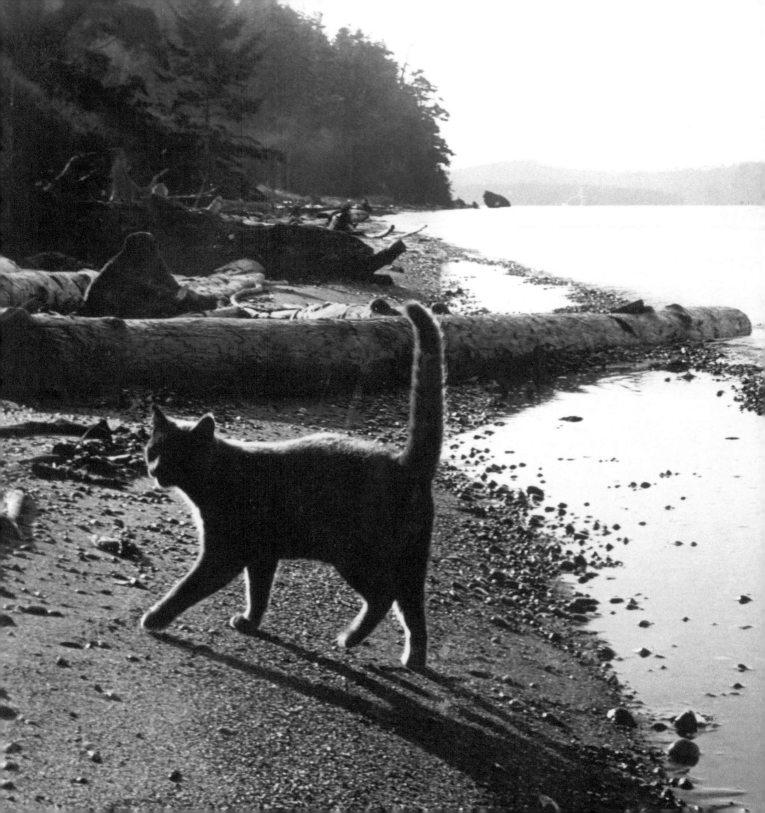

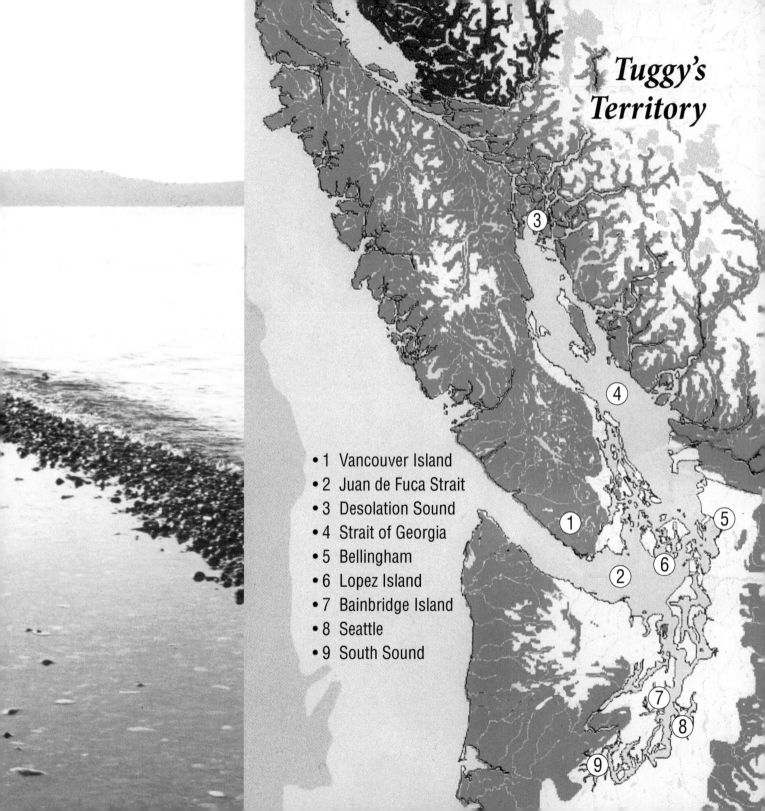

Tuggy's Territory

- 1 Vancouver Island
- 2 Juan de Fuca Strait
- 3 Desolation Sound
- 4 Strait of Georgia
- 5 Bellingham
- 6 Lopez Island
- 7 Bainbridge Island
- 8 Seattle
- 9 South Sound

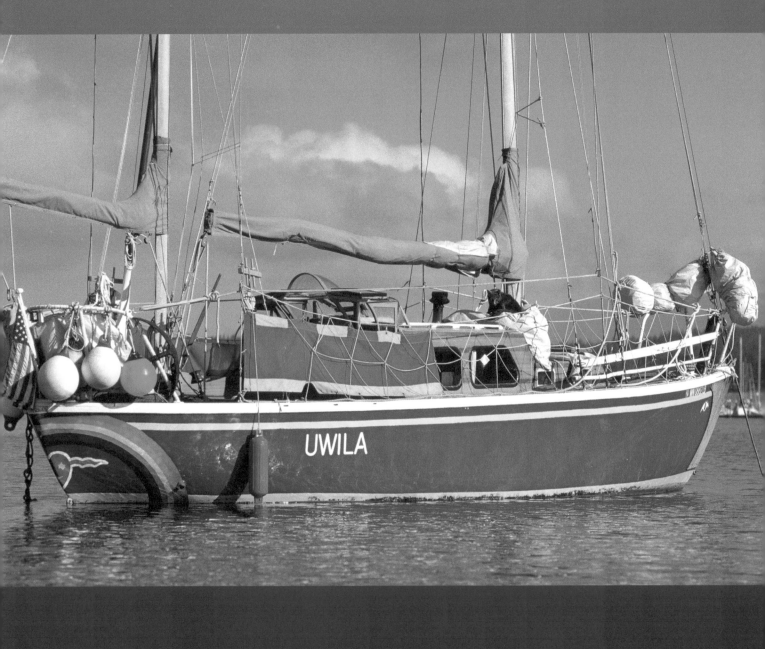

Uwila: an Hawaiian word for lightning, a Polynesian word for the light within, and an Old German word for owl. She, and her twin sistership, were the last wooden boats built at Canoe Cove Shipyard on Vancouver Island, in 1961. Tuggy is washing himself by the main mast.

Preface;
 in which I get a very big surprise,
 and a dream comes true

I believe that many people can make a list of 'unexpected positive changes' in their life. Tuggy was one such event for me. So was the sailboat *Uwila*.

In the spring of 1978, in Bellingham, Washington, I built a seventeen foot Folboat kayak. That summer I spent two months paddling and sailing in British Columbia, Canada. On the way home in the kayak, I visited friends on San Juan Island.

In the fall I created a multi-projector slide show: 'Wind on the Water - Visions of a Water Rat,' about the kayak trip. In January 1979, one of my island friends, Po, arranged a venue for the slide show. Another friend, Stephanie, came along not only to assist me and visit the island, but also to have a brief break from her horse-centered life.

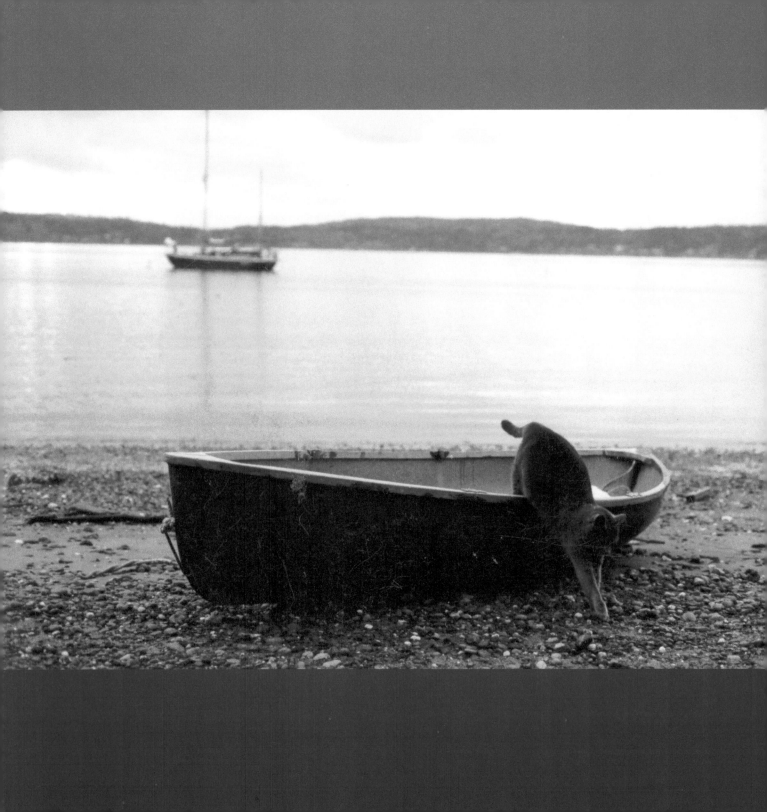

Po called out, "Peter, there's a sailboat for sale out at Roche Harbor that you should see!" When Stephanie and I walked into the restaurant where she worked. Po continued, "It's a thirty foot, wooden, double-ended yawl, named *Uwila*. Dennis is the owner, he lives aboard *Grog*, a Kettenburg Fifty, two slips away. Take my truck, the keys are in it." Po had to repeat herself three times before I fully realized what she was saying.

I was not looking to buy a sailboat...

Uwila was my home for forty-one years.

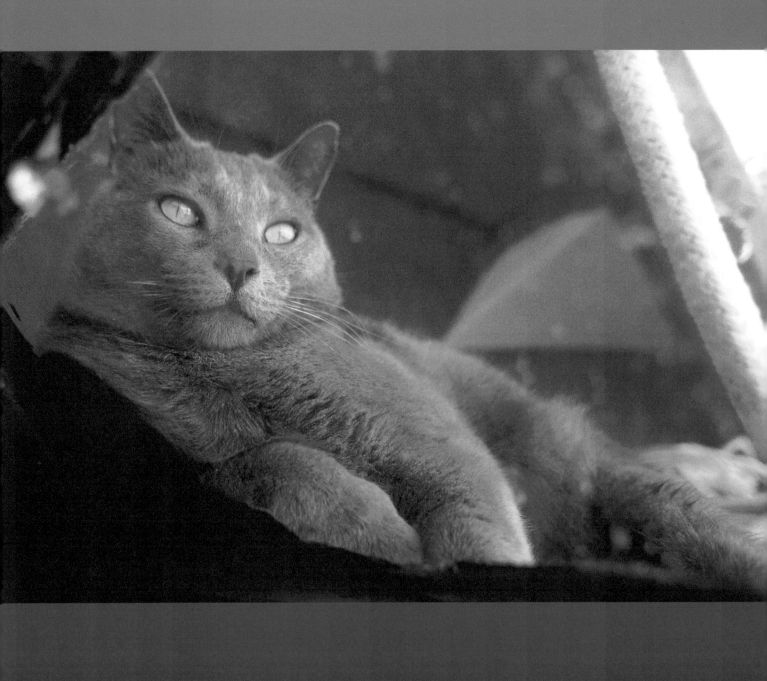

The difference between a Sea Story and a Fairy Tale is how they begin:

A Fairy Tale, most often, is told at home, in the evening, when putting children to bed. Calmly, gently and quietly one says: "Once upon a time . . ."

A Sea Story, on the other hand, is usually told by a group of rowdy sailors who may have been drinking, and tell of adventures they have experienced. Loudly, and with great excitement, one shouts: "NO SHOOT MAN, THIS REALLY HAPPENED! ! !"

All but one of Tuggy's adventures told here are Sea Stories - they really happened.

Islands in the Sun

Introduction;
in which Tuggy's ship comes in, and Uwila and I get a cat

Like many of the best things in life, Tuggy was an unexpected gift.

One September I sailed *Uwila* to Seattle to complete the editing of a film I had shot during the summer. The clients' home had a dock on Lake Washington, where I stayed on the sailboat, editing during the day then showing the revised version in the evening. The project took several weeks to complete, with leisure time for other activities.

While in the city, I visited people I knew who lived there. I called my old friends Claudia and Bill, made plans to go out for dinner at their favorite Mexican restaurant and took the bus to their home. When I got there, after greetings and a brief exchange of news, they introduced me to Tuggy, a five month old kitten - the only of their cat's litter who had not found a home yet.

Tuggy was all gray with large yellow eyes. His mom, Simone, was a Siamese and his dad was an unknown alley cat. Tuggy purred loudly and snuggled into me when Claire, Claudia and Bill's daughter handed the kitten to me. "I think he likes you," Claire said. Claudia told me, "Peter, you should not be living alone any more. You need to have a cat again. Why don't we go for a sail this evening and see how Tuggy likes it." She said this with a knowing smile. So that's what we did.

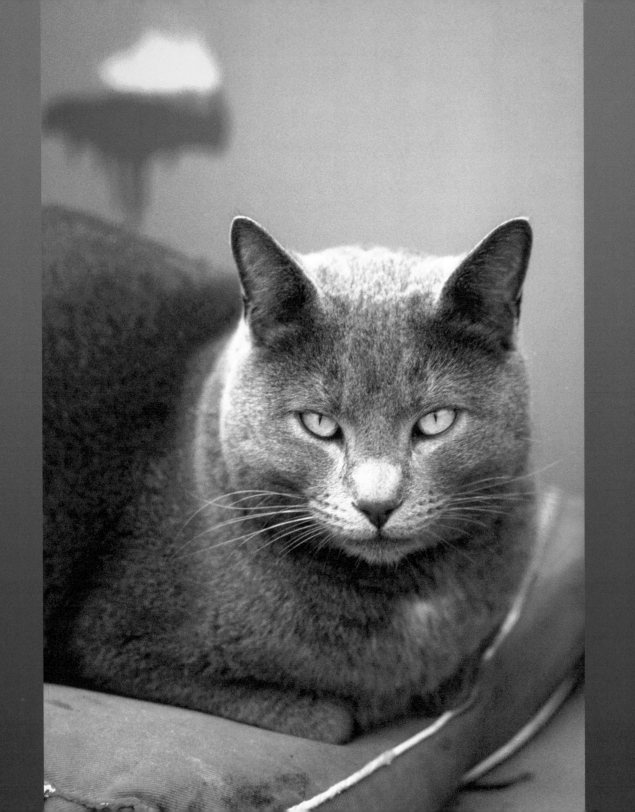

Bill drove us through Seattle to where *Uwila* was docked. Tuggy contentedly curled up in my lap and purred during our car ride through the city. I carried him to the dock and placed him on the boat. "Here you are, Mr. Cat, this is *Uwila* I said gently to him. In the U.S. Navy the word 'Mister' is used to address other officers. I was *Uwila*'s Captain, Tuggy was to be the official Ship's Cat, so that was his nautical title.

Tuggy stood still and looked around: forward and aft, up at the masts and rigging, at the water the boat floated on, the full moon shining in the night sky. Then he slowly walked along the edge of the deck to the bow and back again to the cockpit. He gave a small meow and walked around *Uwila* again before going below to explore the cabin.

I was very relieved, pleased and greatful that Tuggy was not bothered when the engine started, nor did he show any concern when we heeled while sailing. The noises and action of tacking the boat did not bother him either. He stayed in the cockpit all during our sail, making himself comfortable in my lap as often as he could. He was an easy kitten to like, and he seemed to accept me and *Uwila*.

When I got *Uwila*, I had two Siamese cat sisters who loved boat life at the dock and could not have been more uncomfortable when we were underway - poor seasick kitties. Both of them jumped ship for more stable homes. I don't blame them.

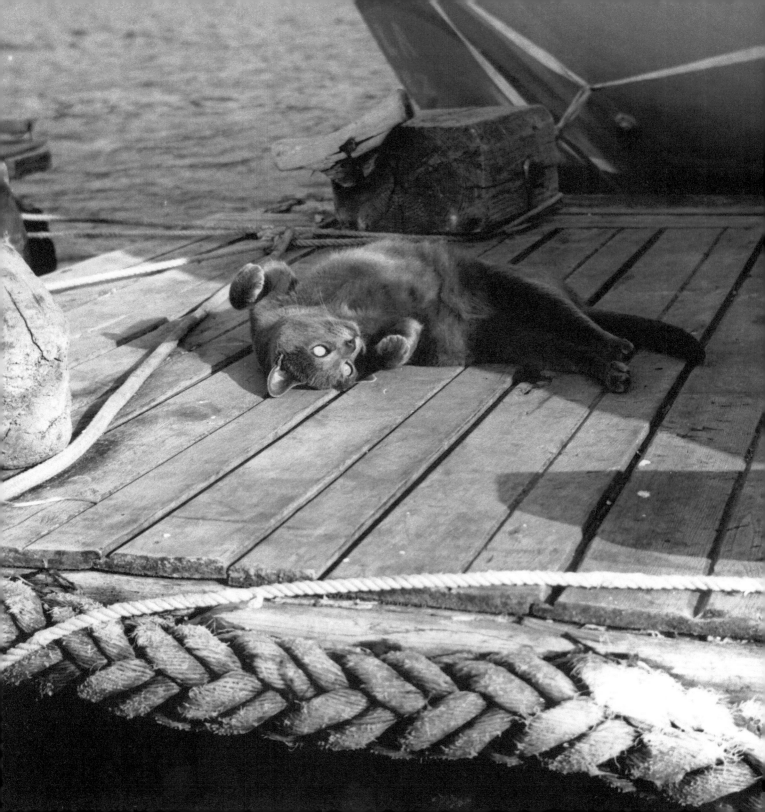

Our family had cats as we grew up. Mom explained that this was to give us experience taking care of other living things, and to learn that everything dies. I had a few cats after leaving home, and enjoyed their company. It was really sweet that Tuggy accepted the boat's motion and noises as normal.

Claire, Claudia and Bill thought Tuggy and I were a good match for each other, and agreed that sailing under the full moon on Lake Washington, and finding a home for their kitten, was a very good reason for not going out to dinner. Maybe we would do that in a few days - we did. When my friends left to drive home, I agreed to call them the next day to let them know how Tuggy and I were getting along.

Tuggy lived with me aboard *Uwila* for ten and a half years. Like most sailors he had adventures. The stories and photographs in this book are an attempt to share them with you, and for me to remember time with Tuggy.

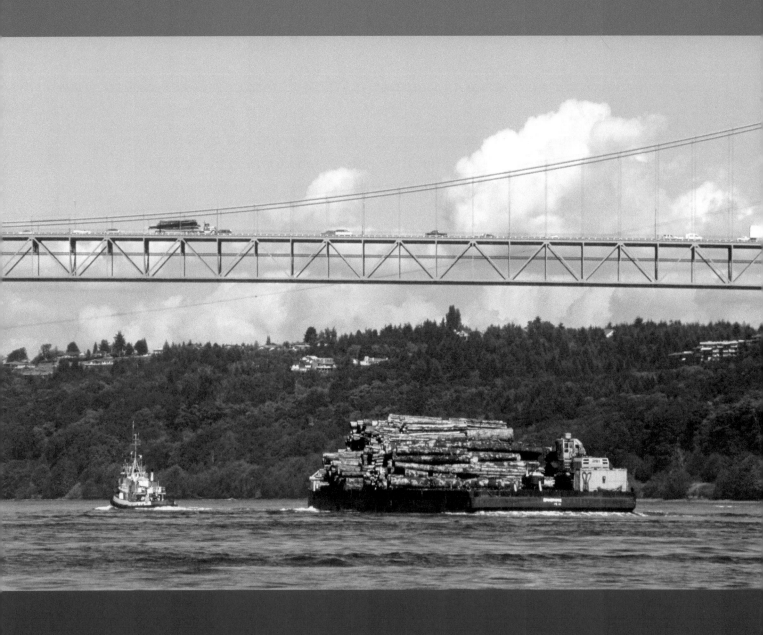

Logs going to the mill

Our First Voyage:
In which we sail home to the islands,
and learn about living together.

While we were still at the dock, and I continued edtiting the film, I told Tuggy about how beautiful the San Juan Islands were and showed him pictures of the flotilla of floating saunas, tetrahedron meditation room, and hot tub I had built, where Uwila would be moored. It was anchored about one hundred and fifty feet from a wooded point with no roads on it where Tuggy could roam around.

On our way home to the Islands something happened which was repeated throughout Tuggy's life aboard Uwila. As we approached the Highway 520 bridge, I said to Tuggy: "Look at that, Mr. Cat. We are going to go right under the bridge. All those cars are full of people going to work, some of them would rather be sailing!"

He stared up at the bridge as we got closer. Just as we motored under it, Tuggy jumped quickly into the cabin and crouched on the floor looking up, as if the greatest monster in the world was about to get him. I told Tuggy there was nothing to be afraid of, but he did not believe me; he had some inherent, deep-seated fear of that huge structure overhead. He never got used to it. Going under bridges was the only experience that upset Tuggy in the years he lived aboard Uwila.

Like other boat lovers, Tuggy repeatedly looked left and right as we went through the Seattle Ship Canal on our way to the locks. There were all kinds of boats to be seen. I never was able to determine which boats were Mr. Cat's favorites, I believe he appreciated them all.

Tuggy stayed in the cockpit with me while we were underway, mostly sleeping on an old red seat cushion flotation device on the bridge deck between the cockpit's footwell and seats, and the cabin's bulkhead. In heavy weather he sat in my lap whenever possible. If I had to trim the sails or move around to do something, I would put Mr. Cat on his cushion and he would stay there until I was settled. Then he would find my lap again.

An old sailing expression is, "Only Admirals and fools sit in the companionway," the entry into the cabin. Tuggy joined this group. That was fine with me. It was important that he be comfortable, and if he wanted to sit there, so be it. However, I taught him to respond to a loud "Tssstt...tssssttt!" from me by moving out of the way quickly because I wanted to get into the cabin, NOW!!

This communication worked well, and was also used when Tuggy was sitting at the very bow of Uwila and I needed to get anchor gear or dock lines out and ready. He was not stupid, and wanted to be good crew. "Tssstt...tssssttt!!" let him know that he was in the way, and Mr. Cat always moved away when so requested. Sitting at the very front of the boat was Tuggy's favorite location for viewing his world. I was proud of him. Mr. Cat was a competent shipmate and good crew. He had his limits, being a cat, but he was a capable and entertaining sailing companion. What more can one ask for?

Our voyage home to the islands was pleasant. We stopped at parks and towns along the way. With Uwila tied to a mooring buoy at Fort Flagler State Park, I got into the dinghy. "Come on, Mr. Cat, jump aboard and we will go to shore." Carefully he leaned over the side of Uwila and leaped onto the stern seat. While I rowed, Tuggy watched for a while, then walked along the bottom of the dinghy to the bow where he carefully climbed up and stood on the wooden side rails like a ship's figurehead. He seemed securely balanced and braced in that position. I hoped he would not fall off, and decided to test him. Suddenly, I rocked the boat and jerked the oars. Tuggy did not fall off, or even slip. But he gave me a look that said: "Don't you ever do that again, sir!" I never did.

When we reached the Park's dock, Tuggy jumped out of the dinghy and we went for a walk on the beach and in the woods. He ran ahead of me and climbed up a tree, then zoomed down the tree past me again. It was on this trip that I taught Tuggy to come when I whistled for him. Or, maybe, he let me know that if I would whistle, he would find me. Whatever. We worked this out so he could go off and know both where I was, and when it was time for us to get together again. I also learned that one of Tuggy's favorite delights was to roll on his back in dry sand, so every opportunity for time on a sandy beach was taken.

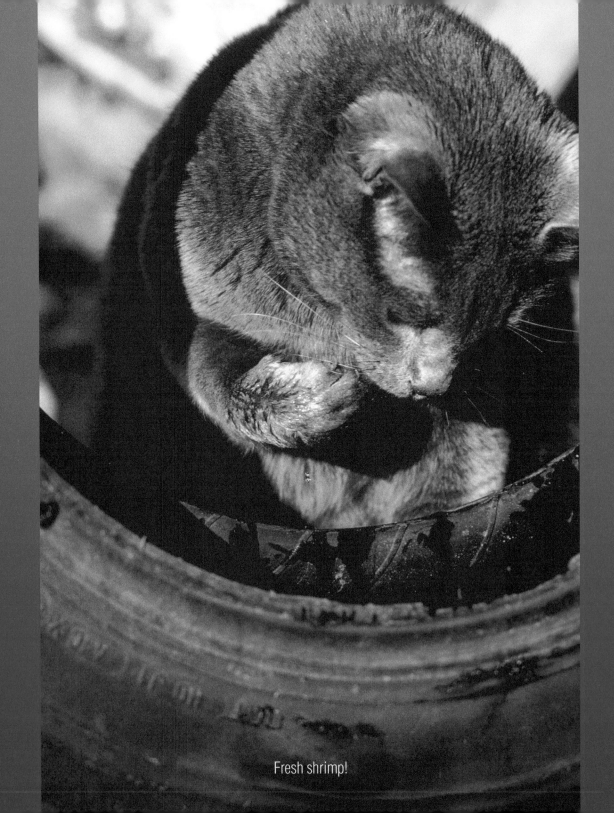

Fresh shrimp!

We stayed a few nights in the Port Townsend area, then made the crossing of Juan de Fuca Strait to the islands in a nice south westerly breeze. I am not sure what Mr. Cat thought about the open water, it is about fifteen miles across, but he did not seem concerned. He paid close attention when we went through Cattle Pass, with islands nearby on either side. Tuggy rode at Uwila's bow when we entered the narrow channel into Fisherman Bay on Lopez Island.

When Uwila landed alongside Crafty Craft, my first floating sauna, Tuggy jumped down onto the dock, explored his new home, then looked towards the shore with interest. "Yes, Mr. Cat, you will get to go there to wander around before too long. First we'll have a sauna this evening." Tuggy was already in the sauna. He climbed up to the highest bench, looked out the windows, and sniffed at the big wood stove. I am not sure he realized how that cedar lined room was to be used. That evening, to his lasting pleasure, Tuggy got thoroughly heated. He always spent time on that highest bench where it was hottest when the sauna was fired up. However, Mr. Cat never jumped into the water to cool down like us foolish people often did.

Occasionally I would pull up one of the car tires which acted as bumpers between the floats, poured out most of the salt water, and set it upright so Tuggy could catch the shrimp that lived in the tires. He would peer intently into the water watching the shrimp, then grab them with his claws. Fresh seafood Mr. Cat caught himself! He did not mind getting his paws wet.

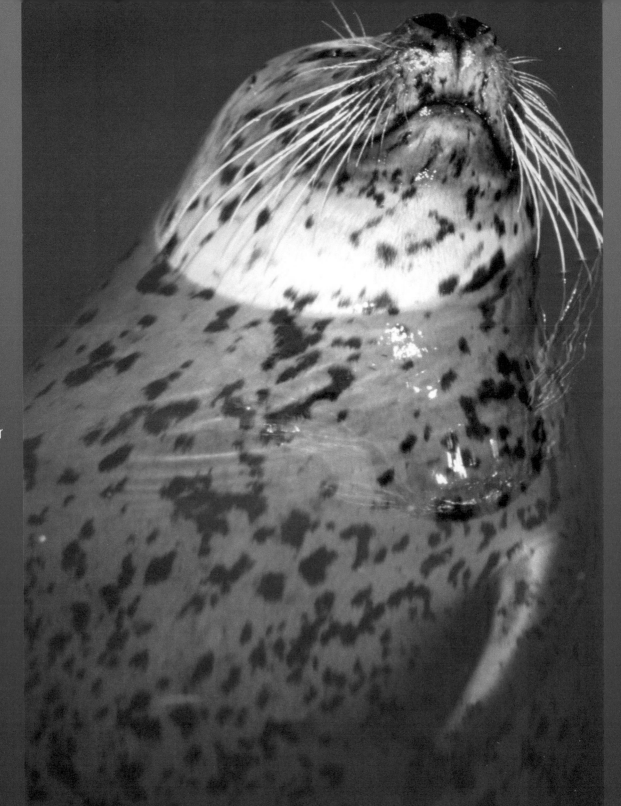

Harbor
Seal

The wildlife of the area interested Tuggy, and sometimes wild animals were interested in him! Harbor seals regularly pop their heads out of the water to look at people in dinghies and kayaks twenty to thirty feet away. When I was rowing Tuggy around the bay, the seals would come up out of the water higher and closer than usual, five to ten feet, to get a better look at the big cat. The ever hungry glaucous winged gulls would gather in large numbers by our float to eat the popcorn I threw out for them. Tuggy, sitting low on the float, would watch them closely while they fed.

One year, a flock of Bonaparte's gulls was in the bay, they are very pretty birds. They seemed to delight in harassing Tuggy, flying low over his head, and making all sorts of raucous, angry calls at him. One afternoon when I got back from work, the gulls were staying away from Uwila. There were feathers all over the dock by our boat, and a carcass: Tuggy, somehow, caught one! He tore it apart and ate the bird in front of its friends and relations. "Back Off! Don't mess with me," the killer cat let the gulls know. They never bothered him after that.

Shortly after Tuggy's arrival in my life, I saw a book titled *How to Raise a Happy Cat*. Flipping it open to see what it had to say, I found: "Never allow your kitten or cat to bite or scratch you." Not my idea of relating to a happy cat.

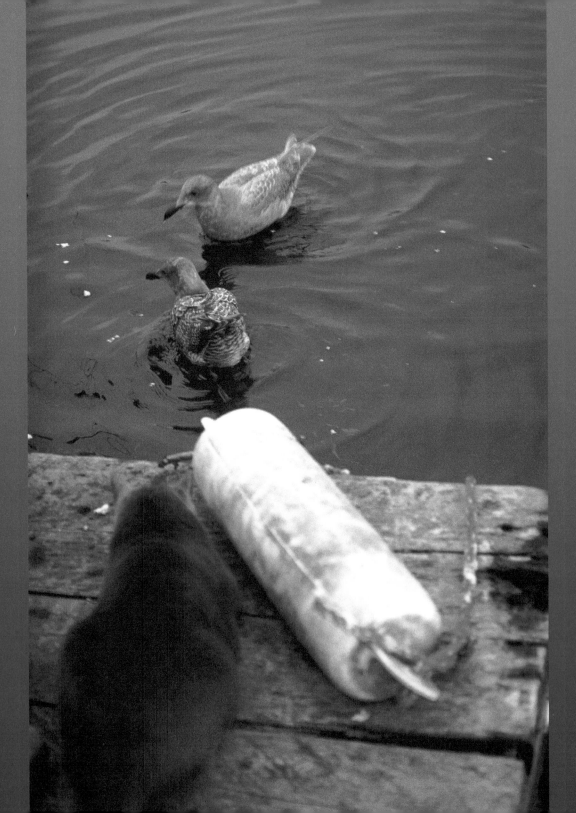

Watching
gulls
eating
popcorn

One of Tuggy's favorite games was to fight with me, biting and scratching my hand in a gentle, friendly way. He would walk around on Uwila's deck and wait for me to pass one of the open portlights, then reach in and grab my shoulder to play. Other times I would put my hand out through the portlight, tap my hand on the deck, and Tuggy would come to attack, scratching and biting the hand that fed him. Every once in a while, I could sense that my big, eighteen pound, cat wanted to be more aggressive, so I wore a thick wool shirt and a heavy leather glove which saved my skin while Tuggy attacked, kicking and biting strongly, without mercy. Mr. Cat was especially cuddly after our rough play.

Many aspects of boat life came easily to Tuggy, but his natural nocturnal ways did not find favor with me. After two nights in a row of being kept awake by his catting around noises, I stayed aboard all the next day and continuously interrupted Tuggy's sleep. I would shake him, and tell him to get up and play, "Oh no, you did not let me sleep last night, I am not letting you sleep today," I explained with a laugh.

Tuggy's eyes would open slowly in disbelief each time I woke him. I also scratched under his chin, petted his back, rubbed his belly, and told him what a good looking cat he was, and how glad I was that he was here. After several hours of this, Tuggy got upset, so the leather glove and wool shirt came out to protect me during further rousings. He did not keep me awake at night after that day of no sleeping for him.

Tuggy was totally at home and comfortable on boats, he was passionate about them. He spent time aboard dinghies, kayaks, day sailors, speed boats, tugs; and he sailed in light airs to gales, in flat water and in the open ocean. He never complained, and was always ready to sit in someone's lap. He seemed to enjoy looking at and being aboard different boats. Whenever Uwila rafted up with another boat, or someone came alongside in a dinghy, Tuggy immediately went aboard to explore. While he usually soon returned to Uwila, Tuggy often found a cozy spot and made himself at home on our neighbor's vessel.

Like all sailors, Tuggy had adventures both afoot and afloat, many of them with some degree of humor. Tuggy was also an outstanding photographic model, he knew he looked good and he knew I liked to take pictures of him; he was simply comfortable being who he was and living his life on a boat with me.

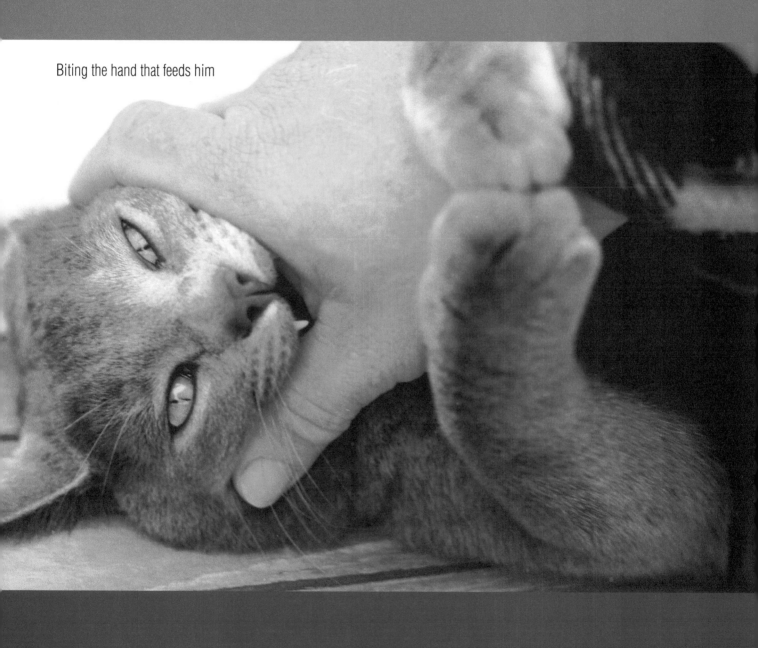

Biting the hand that feeds him

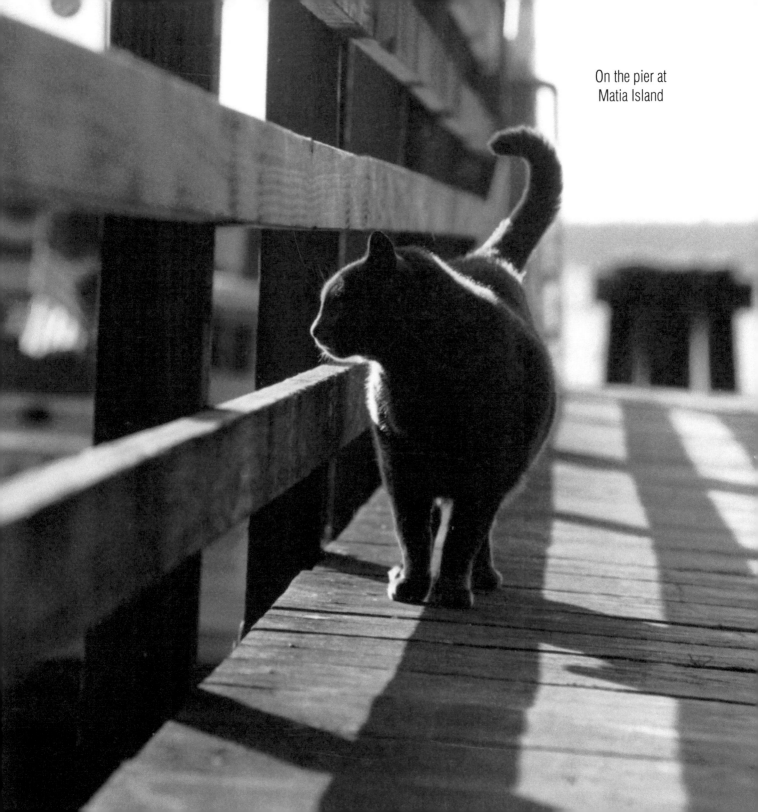

On the pier at
Matia Island

The Mouse at Matia;
in which Tuggy's guest gets fed

Tuggy and I were staying at Matia Island State Park for a few days on our way home from a pleasant visit with friends in Bellingham. It was mid-fall and the big leaf maple leaves were especially beautiful both on their trees and wherever they had fallen in the forest. Spider webs were spectacularly dew-covered in the morning. No other people, or cats, were on the island. Tuggy enjoyed being at the dock, he took himself ashore for long periods every night.

The last night we were there, something woke me up at two in the morning: a scritch, scritch, scritch noise was coming from the cooking stove above my feet. I lay in the bunk and listened more closely. Scritch, scritch, scritch. . . scritch, scritch, scritch. What could be making that particular sound?

I thought about it and figured: Tuggy brought home a mouse, and it was eating food spilled on the aluminum foil by the stove burners. I reached up, turned on a light, and sure enough, there in the stove was a very healthy looking field mouse staring at me. Tuggy sat next to the stove by the galley sink, watching his mouse eating a piece of popcorn.

I reached across the cabin to a pile of clothing and threw a t-shirt onto the mouse. Better to hold a mouse in a shirt than a bare hand. With surprising quickness, the mouse ran out from under the shirt, jumped onto the bunk, and disappeared through an access hole into the engine room. Tuggy looked at me as if to say, "Not too good there, Captain."

I went back to sleep. Thirty minutes later the same sound woke me up again. This time I stood up to throw the t-shirt at the mouse, he zipped away even faster into the engine room. Tuggy had a trace of disappointment in his "I can do much better, no offense sir," look. He did.

I went back to sleep again. Forty minutes later a different sound woke me up: scribble, scribble, scribble. . . scribble, scribble, scribble. What was the mouse into now? I thought a while and decided: the mouse was eating Tuggy's food.

Right again. When I turned on the light, the mouse was in Tuggy's stainless steel food bowl. He would eat several pieces of cat food, then look up at Mr. Cat who was watching him, then eat more. Brave mouse. Every now and then the mouse stood up as if to try to get out of the bowl. Each time the mouse rose, Tuggy gave him a soft 'bip!' with a front paw and knocked the mouse back into the bowl.

Tuggy had caught the mouse, without hurting it, and dropped it into his food bowl where it could not escape. Tuggy just as easily could have put the mouse into the water bowl where it would have drowned. Tuggy looked at me as if to say, "I got him for you, here he is, Boss." "Good work, Mr. Cat," I said.

I got out of the bunk, petted Tuggy's head, pulled out a place mat navigation chart and put it on top of the food bowl, trapping the mouse. Then I got dressed.

Tuggy walked with me as I carried the bowl and his mouse ashore. I turned the bowl upside down near a large cedar tree by the edge of the forest, placed it on the ground, and pulled the place mat away. A bowl of cat food and a brave mouse were dumped onto the ground.

"Bye bye, mouse who had an adventure," I said as I carried both the bowl and Tuggy back to *Uwila*. Tuggy was purring. I filled his bowl with more food and petted him. "Thanks for bringing the mouse to visit *Uwila*, Tuggy. It was generous of you to share your food with him. You are a very good cat, but please don't bring anymore mice home, one was more than enough." Tuggy slept with me for the rest of the night, and in the morning we left Matia Island, and a very well fed mouse.

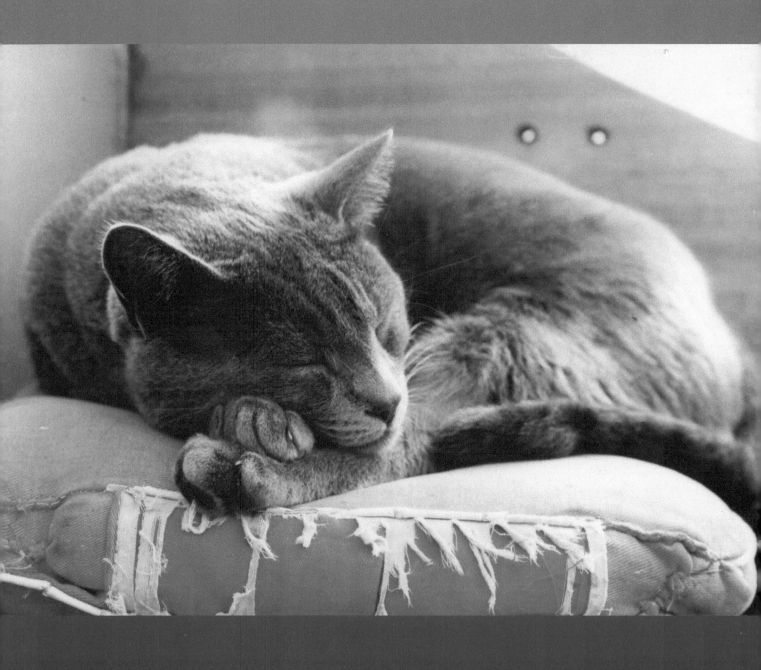

Tuggy Falls Overboard;
in which Tuggy gets a surprise, and I learn a lesson

It was completely my fault that Tuggy fell overboard. I made one of those thoughtless movements which caused Mr. Cat to find himself swimming in the middle of Rosario Strait as *Uwila* and I sailed away from him.

We had stayed several days in beautiful Watmough Bay at the southeast corner of Lopez Island, and were on our way to Cypress Island. We were sailing nicely in about ten knots of wind, with small waves.

Tuggy needed to use his litter box, a plastic tub about eleven by fourteen inches, and six inches deep. Usually it was placed on one of the cockpit seats, but when we were underway it was set on the stern deck, tied with a light line. For some reason, I had moved the box into a position so that part of it was over the side of *Uwila*. I don't know what I was thinking at the time, but I left the litter box hanging over the edge of the boat. When Tuggy stepped into the box it overbalanced and, while I watched, Mr. Cat was rudely dumped into the water!

Reality struck hard. What to do? All of a sudden, there was a crisis of major proportions. No more day dreaming or enjoying the moment, it was time for clear thinking and quick, positive, direct action. We had an emergency, and Tuggy knew what to do faster than me.

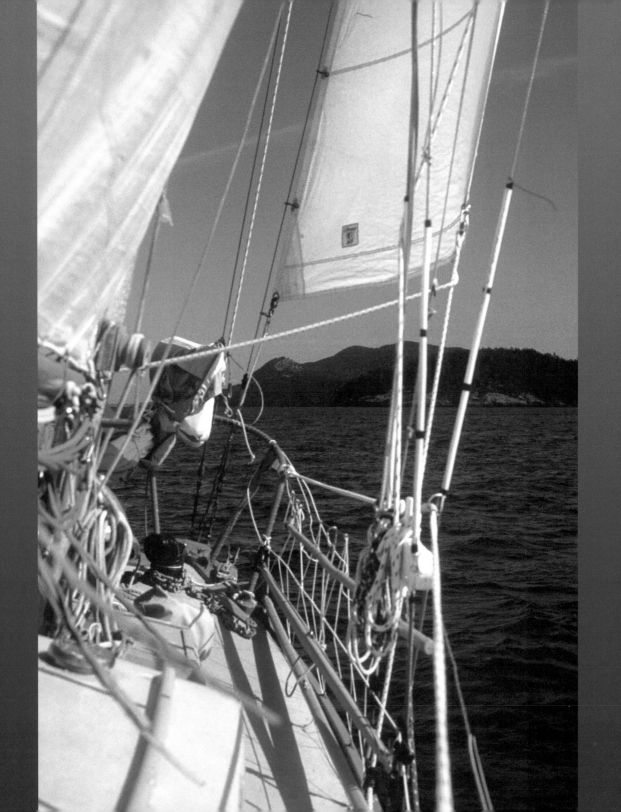

Within moments, we were more than one hundred feet away from each other. My first reaction was to try to sail back to Tuggy. His first reaction was to swim to his boat. I threw him his red flotation cushion, but Mr. Cat swam right past it, and continued towards *Uwila*. I started the motor, put it in gear heading to Tuggy, and dropped the sails. When we were about twenty feet apart, I took the motor out of gear as Tuggy continued his swim. I brought out the fishing net and picked the soaking wet cat out of the water. Safe and home at last. Whew! That was a rush.

While I toweled Tuggy off, I apologized again and again to him. I was very sorry to have been so careless, and quite thankful to have Mr. Cat back aboard again. It was all my fault, and I never made that mistake again.

This experience was one of those strong lessons about procrastination: reef the sail when the thought first comes into your mind; let out more anchor line as soon as the wind pipes up; secure something the moment you notice it may come adrift; eat before you are hungry; drink before you are thirsty; put on more clothes before you are cold; it goes on and on, and I needed yet another reminder. Tuggy, like most animals, got over his experience sooner than I did. However, I noticed that for several weeks, Mr. Cat carefully checked exactly just where his litter box was placed before he used it.

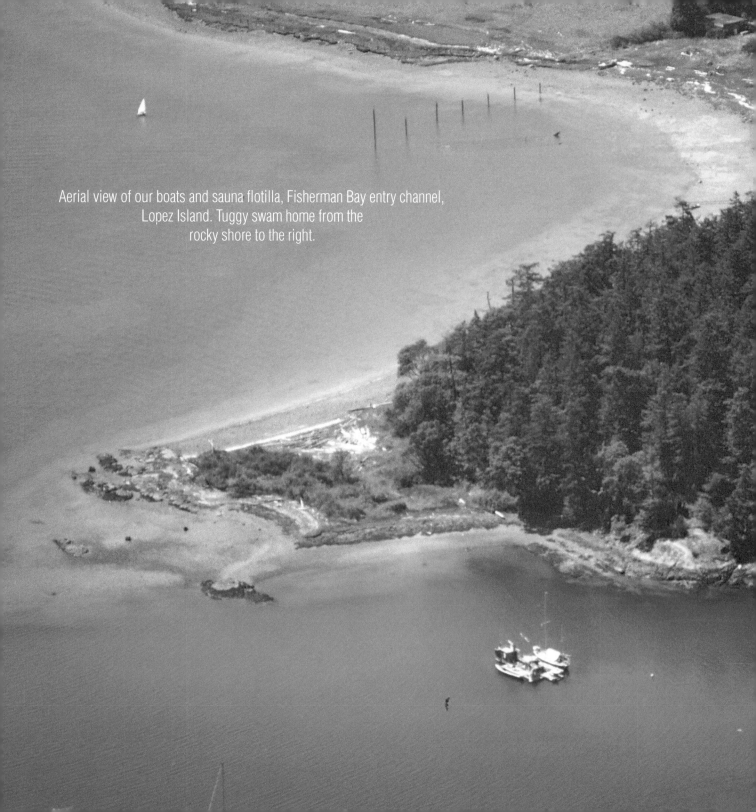

Aerial view of our boats and sauna flotilla, Fisherman Bay entry channel, Lopez Island. Tuggy swam home from the rocky shore to the right.

Tuggy Swims Home;
in which I get a surprise,
and Tuggy learns a new skill

Living was good for Tuggy and me in Fisherman Bay on Lopez. Most of the time when I rowed ashore, Tuggy hopped into the dinghy for shore leave, too. I took him to a rocky point on the peninsula about one hundred and fifty feet away from where our flotilla was moored. He catted around in the woods while I visited people, bought groceries, made phone calls, and generally did chores and other work.

On my return, often after dark, I would row into the cove near where I left Tuggy and whistle for him. He would usually be waiting nearby and give a loud meow. Then I would go to the shore near where his call sounded, and his large, gray, shadowy shape could be seen flowing over the rocks as he came to the dinghy. Sometimes he was too far away to hear my whistle, or was not ready to come home. One time he was almost half a mile away at the very end of the spit by the entry channel, and I barely heard his meow.

If Tuggy was not nearby on the shore when I whistled for him, I went to *Uwila* and whistled again before I went to bed. Sometimes he was ready to come home, sometimes not. Often on awakening in the middle of the night, I whistled and Mr. Cat would be finally ready; I'd get dressed and get him. This was no problem since being out on the water at night was usually beautiful.

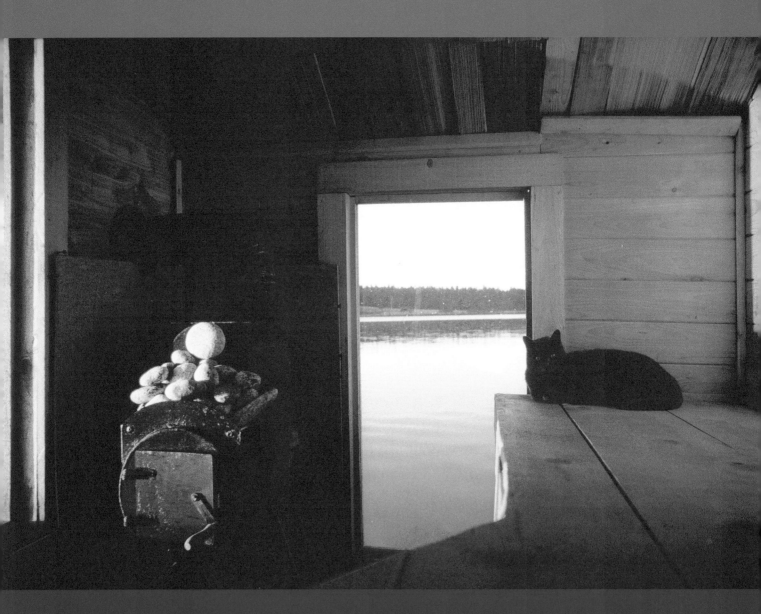

Tuggy in the new sauna at sunset

One evening Tuggy did not answer my whistle. I rowed to the flotilla, then fired up the sauna for a sweat. During a 'cooling down' time outside, I heard Tuggy's meow: "Pick me up in the dinghy now, please, sir." I needed to put some clothes on first. Without thinking too much about it, I whistled to let Mr. Cat know that I would be there to pick him up soon.

While dressing on the sauna's porch, I whistled several more times; again with the thought that I was letting Tuggy know I would be rowing in for him soon. He heard the whistles differently, and thought I was calling him to come to me. I figured this out soon enough.

As I was about to get into the dinghy to row in and get him, I saw Tuggy climb out of the water onto the float the sauna was built on! TUGGY SWAM HOME! Though I saw it, this was difficult to believe. It was a stunning surprise. I never, ever, thought Tuggy would swim home. I carried him into the sauna and dried him off with a warm towel.

Knowing he was independent and didn't need me to give him a ride home, Tuggy swam home about a dozen times in the ten years we lived near that peninsula on Lopez. After swimming to the floats and climbing onto the dock, Mr. Cat would walk forward on *Uwila* and then wake me up by leaning over the open hatch above my head, and dripping cold water on my face. I had gone to sleep looking at the stars, then would be rudely awakened by what I thought was rain. Tuggy's outline against the starry night sky let me know what was really going on.

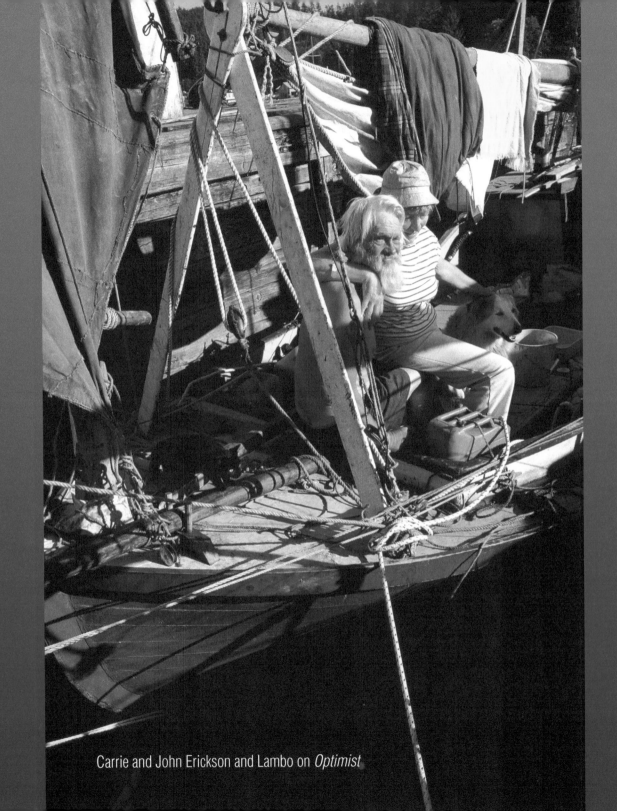

Carrie and John Erickson and Lambo on *Optimist*

Dogs;
in which Tuggy learns that some life forms are friendly and some are not

Tuggy had several encounters with dogs, most of these experiences were positive; once he had to swim for his life.

My brother Garry had a large black and white collie named Hap who was the first dog Tuggy met. Hap was friendly, gentle, knew all about cats, and wanted to play. Mr. Cat did not have any prior knowledge about dogs, so Hap's behavior was welcomed. They got along very well when Garry and Hap came sailing on *Uwila*.

Carrie and John Erickson's collie Lambo was also very friendly towards cats, he lived with three of them at home. John had Lambo well trained, "Sit and stay," were his commands when John rafted his classic Bristol Bay fishing boat *Optimist* alongside *Uwila*. Lambo continued to sit and stay as Tuggy jumped aboard this new boat to explore and visit. "Lie down and stay," John instructed Lambo, and the dog did just that as Tuggy cautiously approached. They sniffed each other, and when John said, "At ease," Lambo relaxed, ate his dog food, drank some water, and mostly ignored Tuggy. Mr. Cat looked all around *Optimist*, giving Lambo a wide berth, then found a sunny spot on the bowsprit where he got comfortable while we people visited. There will be more about John Erickson later.

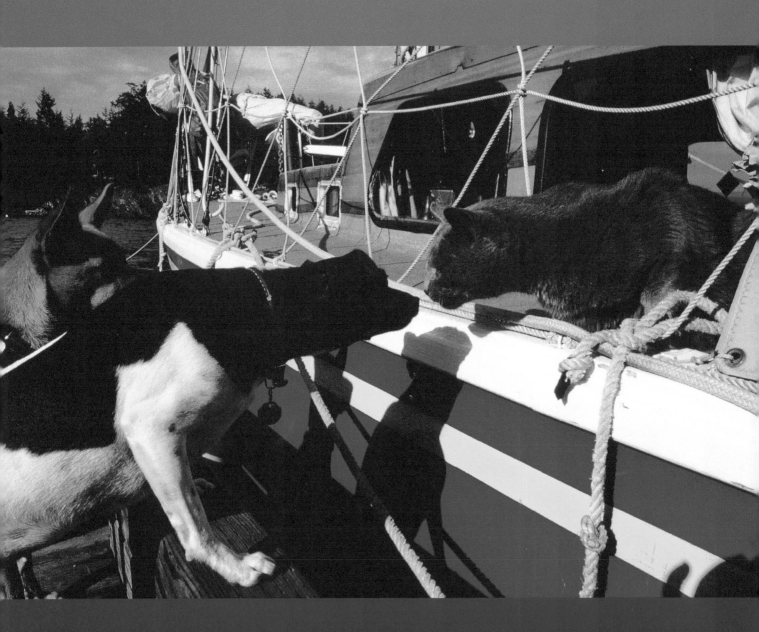
With Coco and Snoopy

Tuggy's next two dog friends were even more loving. *Uwila* was at the tiny dock at Doe Island State Park when a power boat joined us. Two small dogs got off the boat and saw Tuggy watching them from the sailboat's deck. Mr. Cat was a little larger than the dogs, so they came over very slowly and politely to say hello. It was clear that they knew about cats, and respected Tuggy's size and space. Their owner and I watched with keen interest. Both dogs stood up on the dock rail and leaned way over towards *Uwila*, while Tuggy also leaned over so they could sniff each other's noses. First Coco, then Snoopy, not only smelled Tuggy, they licked his nose! It was a very wonderful interspecies communication moment for everyone there.

A much more traumatic dog encounter took place in Eagle Harbor on Bainbridge Island. As I was getting into the dinghy one morning, Tuggy wanted to come ashore too. I took him to the city park where there were trees and bushes for him to hide and play in, then went to do my chores. When I returned to the park, another of the boaters in the harbor had come in and was cutting firewood. Al was a Viet vet who had a small powerboat with three dogs and traveled around Puget Sound living simply.

We visited for a while, then I told Al that I needed to find my cat. "Cat!" he exclaimed. "What does your cat look like?" I described Tuggy, and was very surprised when Al dropped his bow saw, yelled at his dogs to: "STAY RIGHT HERE!!!," and told me to come with him. He said he knew where my cat was! He ran to his boat, fired up the motor, and untied the lines as I got aboard.

Al told me that Blondie, his Great Dane, is a cat killer. When Al began to cut firewood, his three dogs wandered around the park. Blondie sniffed Tuggy out of the bushes. Tuggy ran like a scared cat to the water with the big dog right behind him. Mr. Cat did not hesitate but dove right in and began swimming out into the bay. Luckily Blondie hates water, so he stopped in his tracks at the shore, barking loudly. It only took a moment for this to take place. Al wondered where the big gray cat was going.

Al left his dogs, got in his boat, motored out after Tuggy, and picked the cat up in his fishing net. He dried Tuggy off with one of his towels and took Mr. Cat to a semi derelict barge tied to the shore a quarter of a mile away from the park's dock. He thought this would be a safe place for the wet cat.

We were close to the barge by the time he finished his story. Al shut off his motor and we drifted up against the barge. I whistled loudly and was glad to hear Tuggy's meow. Mr. Cat slowly came into view from behind a pile of lumber on the barge's deck. He walked over to Al's boat, jumped in, meowed hello to Al, and got in my lap.

Al took Tuggy to *Uwila*, then brought me back to the park dock where his three dogs were still lying down right next to his pile of firewood. "Very good dogs!" He said to them, and patted their heads before telling them they could go and play some more. I thanked him very much for helping Tuggy, and for taking me to find Mr. Cat. I rowed home to *Uwila*, went below, and held Tuggy in my lap. "You had another adventure, eh?," I said to him. As usual, he just purred.

Desolation Sound

Tuggy Has a Worm;
in which Tuggy shares something of value with a vet and it saves me some money

The destination for our cruise one fall was Desolation Sound, a spectacular area in British Columbia where deep fjords lead into the Coast Range Mountains, and eight thousand foot peaks are close to the sea. We were a few days away, sailing nicely down wind under spinnaker alone. Tuggy had been sleeping in his usual spot on the old red cushion. He woke up, then stood and meowed several times with a very strange sound. Then he jumped to the cockpit floor and began to throw up.

"It's OK, Mr. Cat," I told him while petting his back. "You get rid of whatever is bothering your tummy. I'll clean it up."

After a minute's worth of stomach contractions and unusual noises, Tuggy threw up a blob of not totally digested cat food. Writhing around inside the mass was a big tapeworm. "Holy Camoly! Good work, Mr. Cat! You don't need that thing in you any more. We better go see a vet." Tuggy returned to his cushion and began to wash himself.

Reflections in Desolation Sound

I picked up the wiggling, white worm with a thin piece of cedar kindling and dropped it into Tuggy's water bowl, then got a bucket of sea water to flush the cat food down the cockpit drain and into the sea. Next I put the now clean worm into an empty plastic film can, where it coiled itself up; then I filled the container with alcohol. I thought the veterinarian would want to see the worm which came out of Tuggy, so he could prescribe the correct medicine to get rid of the worm's relatives.

We were several miles south of Westview, the nearest town. I started the engine and motor-sailed to the marina. There were few empty slips, but I recognized *Silverheels*, a friend's boat, and rafted *Uwila* up alongside. "Hi Peter!" came Bill's voice from inside his boat, he had seen our colorful paint job through the portlight in the engine room where he was busy doing maintenance. I called down to him that I was off on a mission, and would be back before long.

I walked my bicycle up the dock to a telephone booth and called one of the local vets. His office was not too far from the marina. When I got there the doctor gently pulled the dead worm out of the film can with a pair of tweezers. He brought out a tape measure; the worm was fifteen inches long! "There are several kinds of tapeworms. This is a flatworm, and the largest one I have ever seen. Can I keep it?" he asked.

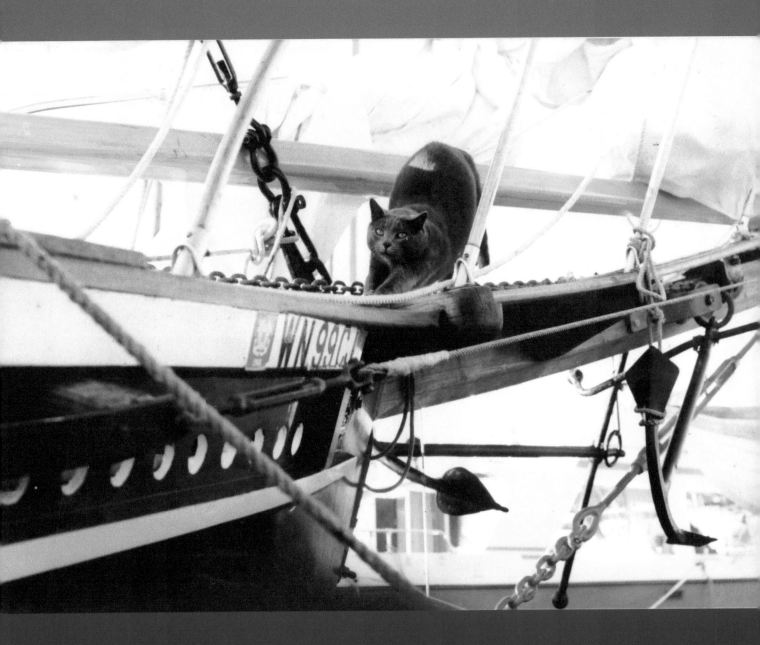

Stretching on *Silverheels'* bowsprit

I was on a tight budget, cruising for eight weeks on sixty dollars. I had already spent half of it on film, food and fuel. "How much will the medicine cost?" I asked. "Twenty dollars," he said. I explained that I was low on funds, and wondered what the worm was worth to him. "Half price," was his response. So I paid him ten dollars and got Mr. Cat's pills. The vet got to keep the largest flatworm he had ever seen.

It was down hill all the way to the marina. When I got there, Bill had finished his work for the day and was showing Tuggy around *Silverheels*. I told them both about the vets' keeping the special worm, and gave Tuggy some of the medicine. While Bill and I had dinner, Mr. Cat stretched, then lay down on *Silverheels*' bowsprit and took a nap. He did not have worms after that, and we had a great time in Desolation Sound.

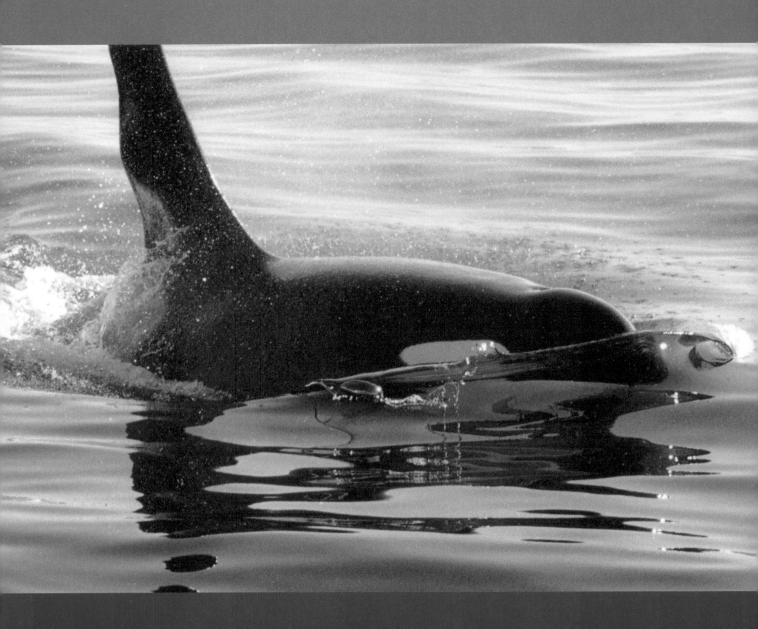

J-1 Ruffles

Tuggy Sees the Whales;
in which huge animals swim by Uwila, and
Mr. Cat puts himself in a very unlikely spot

One January we were sailing back to the San Juan Islands from Bellingham. It was a cloudy, not too cold day with a nice north wind blowing, giving us a down wind sail for the twenty five miles home. There were no other boats out.

After crossing the five mile wide Rosario Strait, we headed into Peavine Pass, between Blakely and Obstruction Islands. Usually this is one of the areas to motor through, today we could sail - down wind!

Tuggy was curled up in a ball, sleeping under the down vest I bought him at a thrift store to keep him warm. As I glanced forward to check the wind patterns through the pass, I saw spouts and dorsal fins. Killer whales were swimming towards us! Keeping track of our approaching courses, I figured that we would cross paths near the entrance to the pass.

When the orcas were about two hundred feet away, I picked up Tuggy, scratched him under the chin, and set him down on the cabin top facing forward. I said, "Look ahead, Mr. Cat. Killer whales are going to come by our boat!"

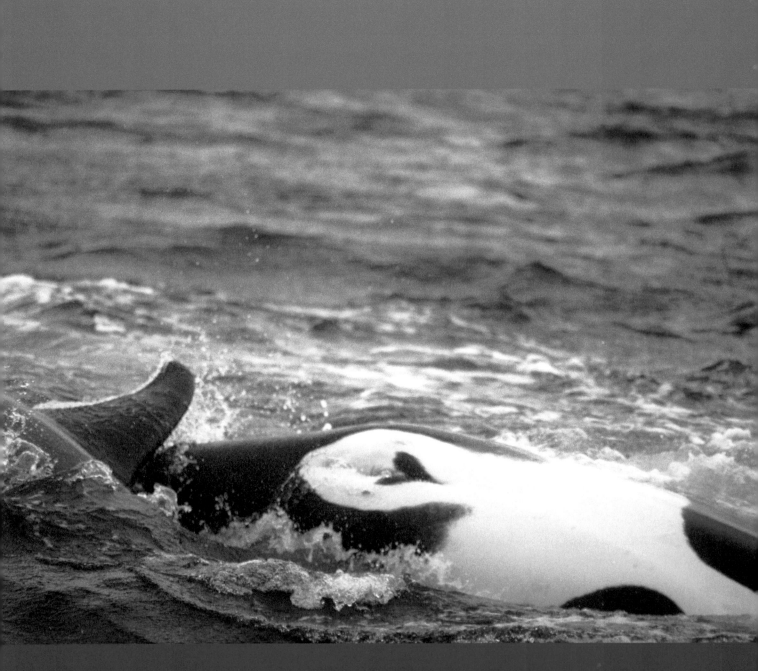

Belly Rub - An adult female killer whale upside down, and a young whale - perhaps her calf, rubbing its' dorsal fin along the length of the female's belly. They are very tactile animals.

In his independent, cat-like way, Tuggy looked up at the sails as if to check that they were trimmed properly. Then he looked towards Obstruction Island as if to gauge our distance from its rocky shore. Finally he gazed astern at Cypress Island, perhaps remembering the day we hiked up to Eagle Cliff. Tuggy jumped down into the cockpit, walked to his usual spot and began to wash himself.

"Oh no, Mr. Cat, this is a unique opportunity. You've never seen killer whales before. And they probably have not seen an all gray cat with yellow eyes," I told him.

Once more I picked Tuggy up and placed him on the cabin top facing forward. The whales, at least seven of them, were now one hundred feet away. The sound of their blows could be heard as we sailed silently towards them.

Again, the first thing Tuggy did was to look up at the sails. Then he glanced over the side at the water flowing past us. Next he looked behind us to watch a glaucous winged gull soar down to the water's level and high into the air. I told him, "Tuggy, you do not want to miss this chance to see these whales. But it is your choice of where you look."

Now Tuggy jumped down to the deck on the side of the boat that the whales were going to swim by and slowly walked to the aft end of the cockpit. He sat down low with his head looking out behind the weather cloth by the side of the cockpit.

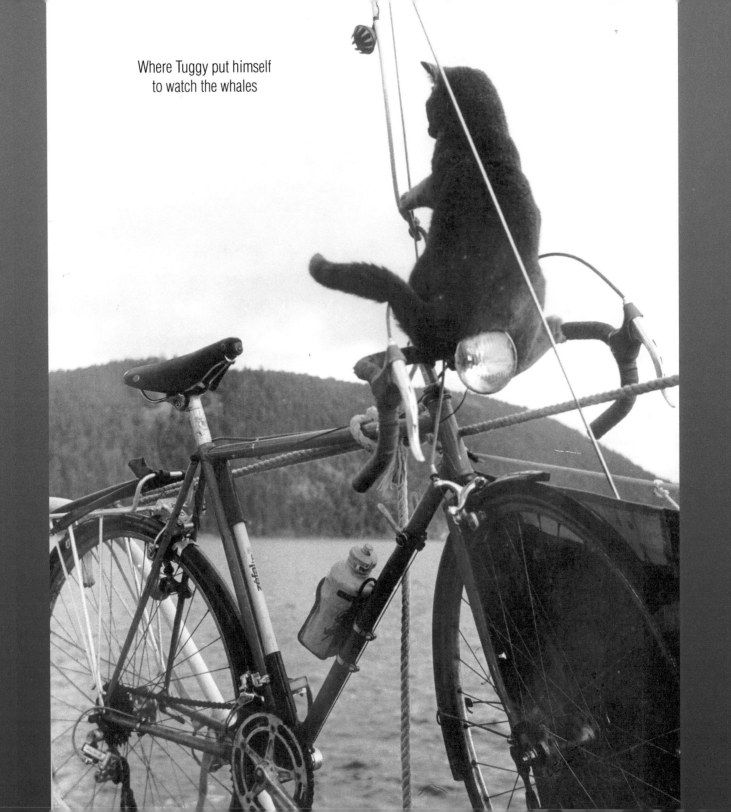

Where Tuggy put himself
to watch the whales

Tuggy's head was extending over the edge of the boat when the lead whale surfaced directly alongside us, fifty feet away. Mr. Cat instantly crouched down as low as he could get to the deck. His eyes were open wide.

The whales continued swimming by as we sailed into the pass. The closest orca was thirty feet away when she surfaced and rolled onto her side to look at the boat. She seemed to be focusing on Tuggy's head, his eyes certainly were glued to the whale!

Right above him, lashed to the mizzen mast stays, was my ten speed road racing bicycle. After the whales swam by us, Tuggy climbed up onto the bike!!! He stepped onto one of the pedals, then the water bottle cage on the down tube, and up onto the handle bars! He set himself with one back foot where the stem meets the bars and the other foot balancing himself to the right, with his tail out to the left. He then sat up on his haunches and held onto the wire stay with his left front paw, and from this elevated position Tuggy watched the whales for ten minutes.

When the whales' fins were small specks in the distance, Tuggy carefully lowered himself to the deck, walked into the cockpit and rubbed against me with a small meow. Then he went back to his red cushion and washed himself before curling up into a ball under his down vest and falling asleep. He was purring loudly.

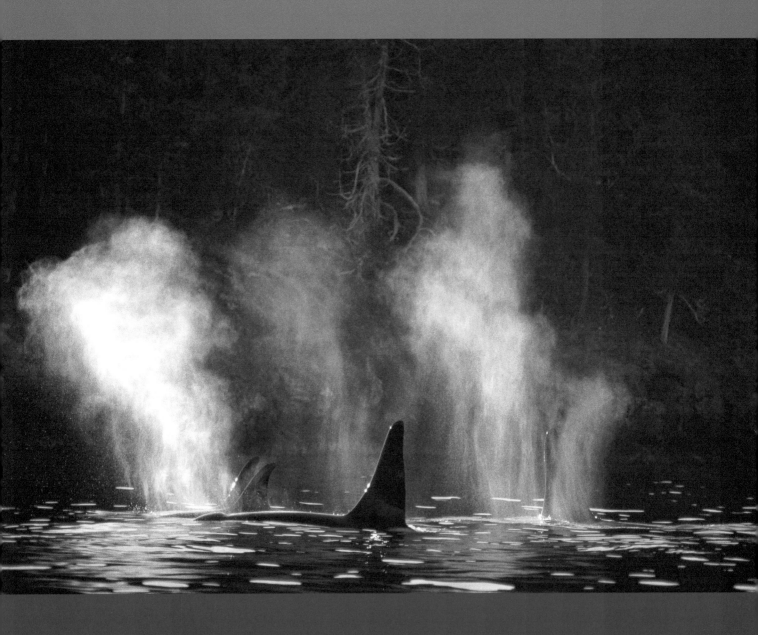

Orca Blow #3

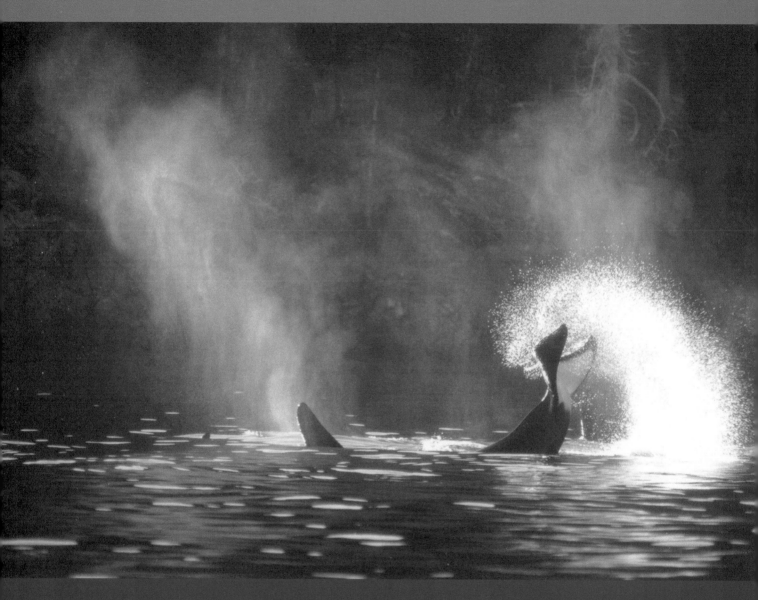

Tail Lob - At the 2001 Biennial Conference on the Biology of Marine Mammals in Vancouver, B.C. one of the scientists looked at this picture for a long time before purchasing the large print. He told me that his field of study was of the muscular structure in Cetaceans' tails (whales, dolphins and porpoises), and that he had never before seen a photo showing so much curvature in one of their tails. He was unaware that the tail could bend so much. This photograph is a scientific breakthrough.

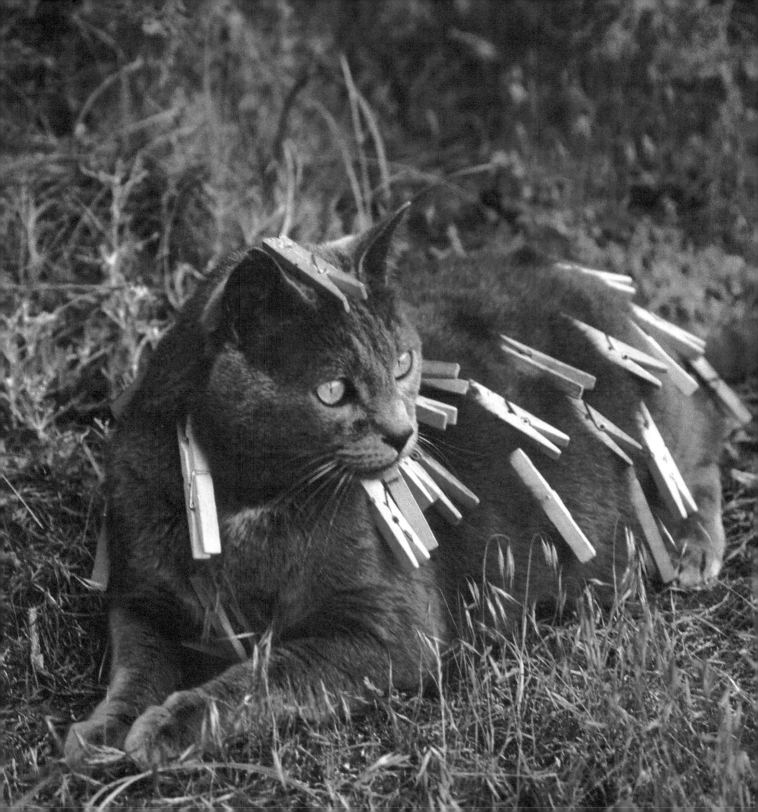

Clothes Pins;
in which Tuggy accepts appearing unusual so people can feel joy

Laugh – it's all right to laugh when you see Tuggy covered with clothes pins, laughter was our intention. Before you judge this cruel, look again: is Tuggy bothered by having these things attached to his fur? No, not at all. Look again and laugh, but before putting clothes pins on your cat, read this story.

As I explained earlier, Tuggy's spot while we were underway in *Uwila* was either in the companionway or right next to it. Just inside the cabin on the overhead, charts were stored for whatever area we were in. And on the bungee cords which held the charts up, were half a dozen clothes pins attached ready for quick use.

While we were sailing back and forth across Boundary Pass one summer day, I thought of putting a clothes pin on Tuggy. It would be funny, I would laugh, and Tuggy liked it when I laughed. So, petting him first, I attached a pin to the gray fur on his side and continue to pet him. Tuggy stretched his head over, opened his mouth, bit the offending object, and pulled the pin off. I petted Mr. Cat and put the pin back on him, then petted him and laughed. He pulled the clothes pin off, I put it back again, several times. We continued this until Tuggy had enough of my foolishness, got up, and walked away.

Over the course of several months I conditioned Tuggy to accept being covered with clothes pins. I always petted him, and told him how handsome he looked with these wooden things decorating him. And, I always laughed and felt good while doing this. It was one of the games we played. Sometimes, when Tuggy appeared to be bored or restless in the cabin, I'd toss a clothes pin to him, and he would bat it around for a while. Tuggy also chewed on them. There are still several clothes pins with Mr. Cat's tooth marks aboard *Uwila*.

Laughter is supposed to be one of the healthiest activities humans can experience: I believe this is what the dolphins and whales, and other life forms, are trying to teach us. Without being cruel, just about anything that can make us laugh must be good. Tuggy did not mind being laughed at when I showed friends how nice he looked with clothes pins on him. It will be very good if you laugh again at the picture.

This photo is part of a series I took in Smuggler's Cove Provincial Park in British Columbia. *Uwila* was at anchor. I rowed Tuggy ashore and we walked up to a mossy area where I petted him, covered him with clothes pins, and took a lot of pictures. Mr. Cat was very co-operative, as usual. Two other boats were rafted together at anchor in the Cove, and one of the people was watching through binoculars and reporting:

"He's covering his cat with clothes pins!!! Now he's taking pictures of the cat! Take a look!" I laughed loudly enough for them to hear me, and they laughed, too. You can laugh with us, also.

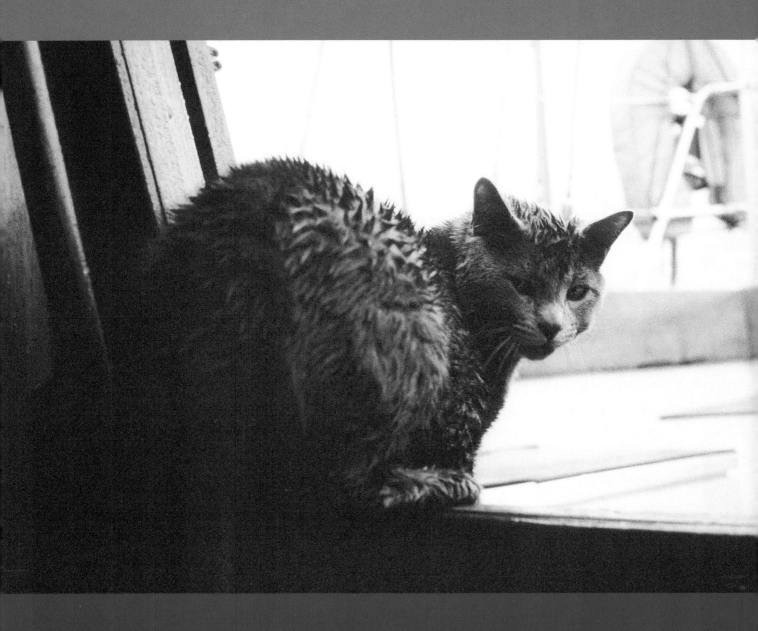

Wet cat on *Tiger Lily* - after being pooped

Vancouver Island;
in which we sail aboard another boat,
ate well and had adventures

One spring, I was crew, cook, and comedian for a month on the West Coast of Vancouver Island, perhaps the premier sailing area in the Pacific Northwest. Tuggy came along for the ride. We were aboard *Tiger Lily*, a Cheoy Lee forty one foot yawl, with Ed and Jim, two sixty four year old Republican gentlemen. I was a thirty eight year old "over-fed, long haired leaping gnome" with a good brain, who loved to sail. We got along just fine. Also sailing in company with us were Ed's sister, Mary, and her husband, John, on their boat *Sandpiper*.

On the second day out from Victoria, B.C. we got bounced around pretty well in a gale. This was the first heavy weather Tuggy experienced, and I was little help to him. Early in the day I had gotten soaking wet, and very cold. When I went below to find dry clothes, the ocean motion got to me, and sea sickness hit hard. I spent several hours lying down, when I was not feeding the fishes.

Tuggy hunkered himself on the floor of the cockpit. This was a good place until *Tiger Lily* was pooped. A big wave came aboard over the stern, uninvited, filling the cockpit. The water quickly drained out, back to where it belonged,

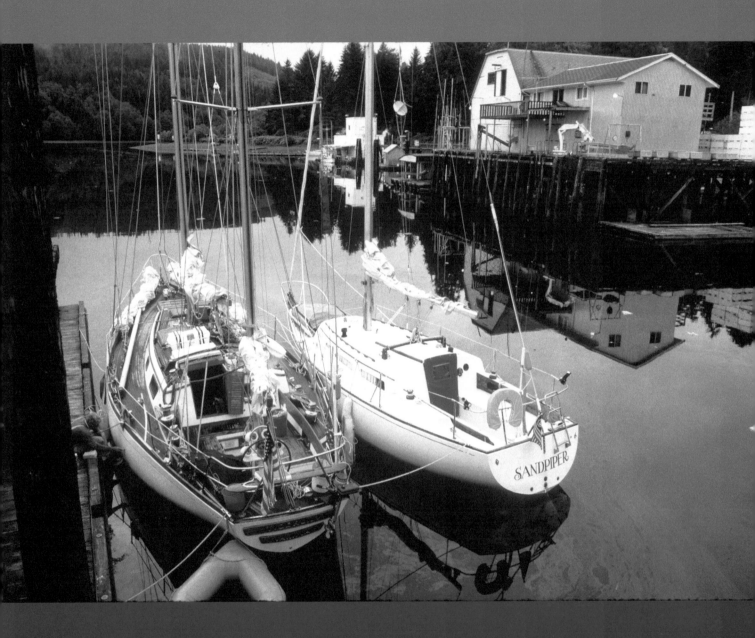

Tiger Lily and *Sandpiper* at the dock in Winter Harbour, B.C. Tuggy is in the companionway, while Jim cleans the hull.

and Tuggy swam around in until it reeceeded. I was not too sick to take a photo of a soaking wet cat. Tuggy was not happy. After taking the photo I brought him below, dried him off, and cuddled with Mr. Cat until we both felt better. That was the worst weather of the trip.

Tuggy and I went for walks on many of the islands, and one night while at a dock, "That damned cat!" brought a mouse aboard *Tiger Lily* and chased it all around the deck while we were trying to sleep. Thank goodness Mr. Cat did not bring this mouse down below into the cabin of Jim's boat!

On this trip, Tuggy got his choice of seafood several times. We experimented to learn which were his favorites. Deciding between salmon, halibut, ling cod, rock cod, and red snapper, all cooked and cold; Mr. Cat first ate all the halibut, then the ling cod. Red snapper was his third choice, then he was full and went to sleep. Another day he got to select again from oysters, butter clams, Manila clams, shrimp, scallops, and Dungeness crab again; all cooked and cold. Crab, scallops, shrimp, and oysters was the order of his feeding. And again, after eating all that rich food, he slept soundly.

Tuggy especially liked crab. He would wait patiently while I removed the meat from the shell. Secure enough to know that this delightful food was being prepared for him, a cat's meow! was not necessary.

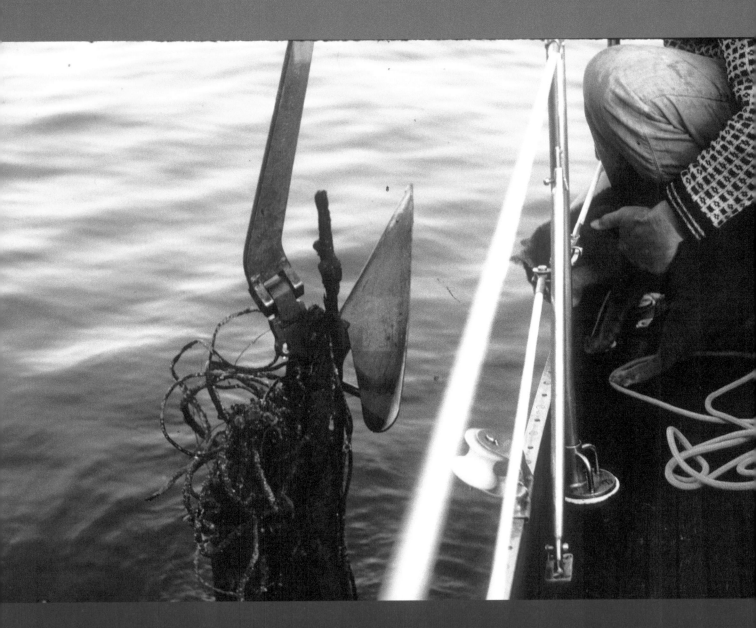

Fouled anchor

One morning, I noticed that *Tiger Lily's* anchor windlass was straining much more than usual when I was using it to raise the anchor. I called to Jim and Ed to let them know we might have fouled the anchor on something. Sure enough, when it got close enough to see, there was an old car tire and a bunch of wire cable on the anchor. Jim stayed at the helm while Ed and I rigged a line from the spinnaker halyard to the anchor, let out a bunch of chain for slack, and brought the anchor alongside. Using two boat hooks and our hands, Ed and I worked for half an hour to free the anchor from the stuff on it.

Tuggy closely watched the operation with great curiosity and interest. While Mr. Cat had seen many fish landed, as well as crab and shrimp pots brought up from the sea; he had never before seen an anchor bring anything up from the ocean's floor.

After this trip, where we sailed in the swells of the open Pacific Ocean', Tuggy and I appreciated how protected the waters in the San Juan Islands are.

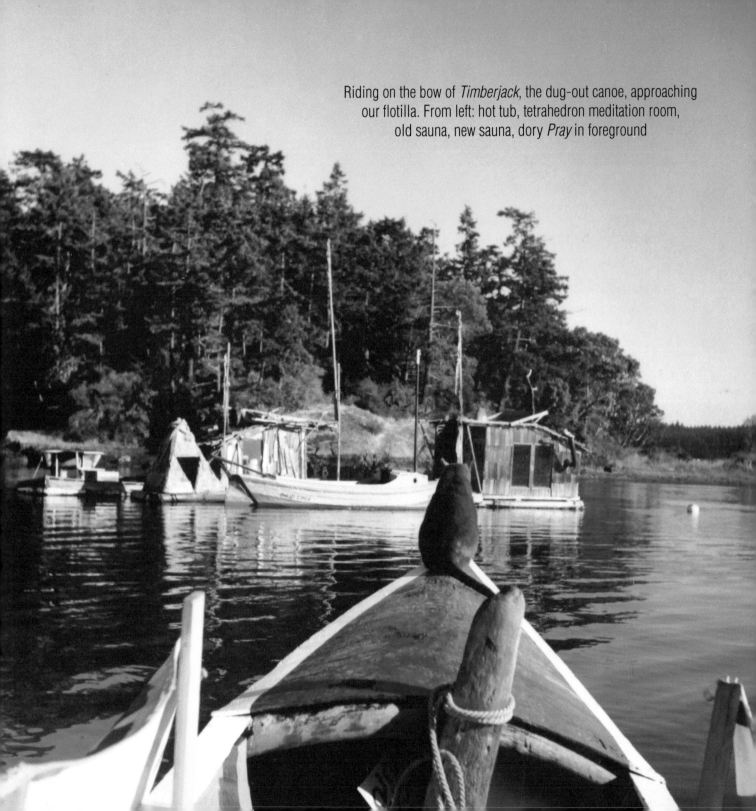

Riding on the bow of *Timberjack*, the dug-out canoe, approaching our flotilla. From left: hot tub, tetrahedron meditation room, old sauna, new sauna, dory *Pray* in foreground

The Alternate Universe;
in which Tuggy goes some place else,
and is photographed there

After ten and one-half years of being shipmates, Tuggy got sick one spring. He stopped eating and did not move around much, so I took him to the vet. He thought Mr. Cat had cancer. I took Tuggy to another vet who reached the same conclusion. I spoke with two additional veterinarians and learned about what medical magic could, and could not, be done for Tuggy. Kitty cancer operations are rare. Everything dies.

I did all I could to bring happiness and joy to Tuggy for the last weeks of his life. We got special permission to visit a very private beach for his sand rolling pleasure. Many people who knew and loved him came by to visit one last time. I took Tuggy rowing around the harbor so he could watch wildlife. Plans were made with Jessica, Tuggy's favorite vet, to come to *Uwila* for his lethal injections. It was a challenging and interesting time.

Tuggy died in my lap aboard *Uwila*, and I buried him at the top of the gravel pit hill, Missing Mount Baldy. A great view to the south of the Olympic Mountains, American Camp National Park and Griffin Bay. To the north are Friday Harbor, San Juan Channel, Orcas Island, and the Canadian Coast Mountains; our cruising territory. Crocus, daffodil, and jonquil bulbs were planted in a circle around his grave. I visit the site several times a year. It is a good place to fly a kite, and remember the great times we had.

For the memorial photograph to live with aboard *Uwila*, I chose
one showing Tuggy sitting at the bow of *Timberjack*, the dug-out canoe,
approaching our real life water world. When I picked up the enlargement
I had ordered, I noticed it had been printed backwards! I first thought
they would be only too happy to print it again correctly, but then
I laughed. Who cares if it is reversed? Really now?

As I was leaving the store, I saw Jessica the vet. I showed her the
memorial photograph, and told her the joke about it being backwards.
Jessica stared at it intently, and smiled like an impish angel before
laughing and proclaiming:

"THE ALTERNATE UNIVERSE IS REAL!!!"

She is correct, of course. That is where life forms exist after,
and before, spending time here on Earth. This picture shows
Tuggy doing well there.

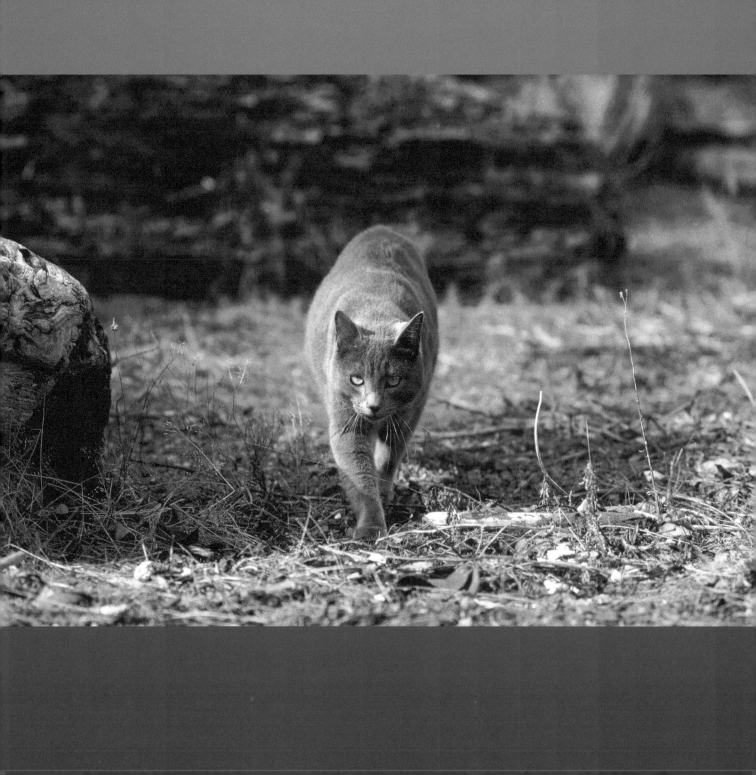

The Legend of the Puget Sound Panther; in which we meet a most fascinating person, and learn something really cool

There are many breeds of large cats. The Maine Coon Cat and the Norwegian Forest Cat both weigh up to thirty five pounds. Tuggy looked like a Russian Blue, but at eighteen pounds was much heavier. Over the years we met several other big gray cats with yellow eyes: Graybear weighed twenty six pounds; Smokey was twenty four pounds; Silver was twenty three pounds; and, Otto was twenty pounds. The people with these cats, and I, often wondered if our cats were a breed apart. They are.

South Sound, as those waters south of Tacoma, Washington are known, is a fine cruising area. There are many parks, small towns, few cities, beautiful scenery, a strong history, and often good sailing. Like many areas in this part of the world, powerful connections with nature and spirit can be felt. One year Tuggy and I spent three months cruising South Sound in the fall and early winter. I did a lot of reading, writing, and photography. We went for long walks, had some wonderful sailing, visited old friends. And we met someone who taught us about large gray cats with yellow eyes.

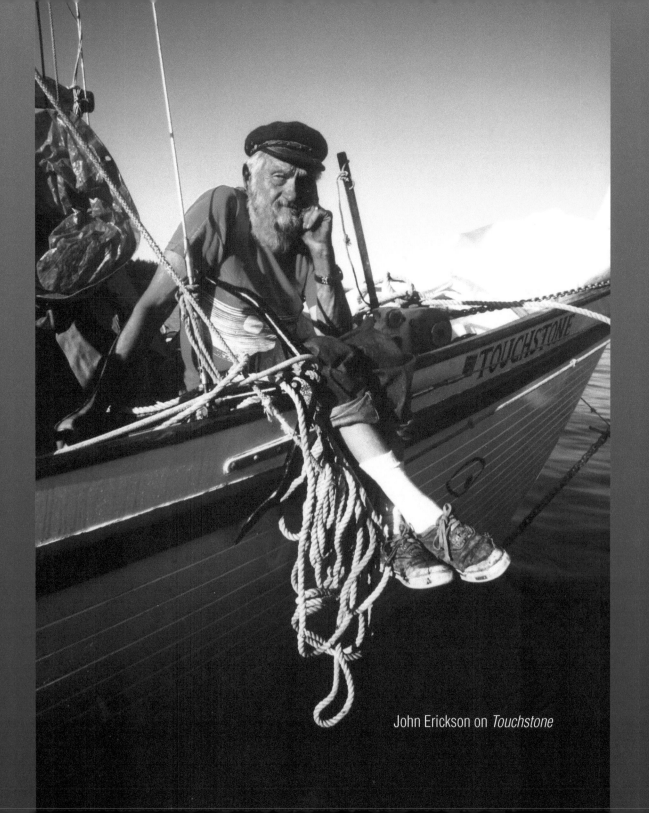

John Erickson on *Touchstone*

Uwila, *Timberjack* the dug-out canoe I had saved and restored, Tuggy, and I were at Hartstine Island for two weeks while visiting our great friend and former shipmate, John Erickson. We met years earlier when John and his daughter Jane, were sailing to Princess Louisa Inlet aboard their engine-less Bristol Bay boat. At that time *Optimist* was sailing as a cutter; in later years she was sailed as a lug-rigged yawl, and also a gaff schooner. John loved to try different rigs on the same boat.

He had a career in the U.S. Navy, and sailed on local boats wherever on the planet he was stationed. John was a prime example of not judging someone by their, or their boat's, appearance. Once out of the military, John reverted to being: "The slob I always wanted to be!" How he looked was not important to him. This was part of John's disguise, hiding a very capable, intelligent, and experienced, Lieutenant Commander.

To the great chagrin of the more spit-and-polished style yachtsmen, John, aboard his Phillip Rhodes 'Traveler' *Touchstone*, placed first in the sailing regatta one year at the Victoria B.C. Classic Boat Festival. *Touchstone* was simply sailed better, no matter how cluttered she looked. Like *Optimist*, her deck was strewn with bags of dog food, bags of trash waiting to be taken to the dumpster, crab pots, firewood, anchors, mis-matched lines, boxes of full beer bottles and boxes of empty beer bottles; she was captained by a long haired, long-bearded, beach bum looking guy.

Turn
Point
Road,
Stuart
Island

John and I were good friends, and he loved Tuggy, calling Mr. Cat: "One of, if not the, ultimate ship's cats I have ever had the pleasure of knowing". Over the years we sailed on each other's boats in several areas; John joined me aboard *Uwila* for a three week trip to Barkley Sound on the West Coast of Vancouver Island. It was a fine pleasure to spend so much time with John, his 'bride' Carrie, and Jane on this trip to South Sound.

One evening we got to talking about where Tuggy and I were off to next. "And have you been around Squaxin Island, yet? You will want to spend time there." John told me: "There are some things in that area that do not meet the eye at first. Be sure to take the time to get out in *Timberjack* and cruise the inlets at high tide. I think you and Tuggy will enjoy those waters. You might find some interesting things, and maybe a few people you won't forget." With that sort of introduction, the island was our destination when we left a few days later.

There was a nice north wind, giving us a great sail south in Case Inlet, then through Dana Passage. Around the end of the island the wind got much lighter, but with the flood current we continued to make our way north west in Squaxin Passage. The motor got us to anchor in a big open bay on the island. After a clear, starry night, the morning dawned foggy which made exploring the wooded shores all the more inviting. I packed a lunch, put Tuggy's food and water bowls in *Timberjack*, and off we went.

In areas where large waves do not form, many trees stretch their branches out over the water getting all the light they can. At high tide the water is just below their boughs. Cedar trees are especially good at reaching out, the bottom of their branches make beautiful, graceful curves reflected in calm water.

It was a few hours before high tide, so there were several feet of space between the trees and the green water. We could sometimes glide under the limbs. On our right side was smooth water and thick fog. To the left was a forest of cedars, those long branches far out over the water, their tops up in the fog. The outboard was at idle speed. Tuggy, as usual, rode on the bow of the dug-out canoe.

We followed the wooded shore for several miles through the fog. It was very beautiful and peaceful. Then the woods stopped at the edge a rock cliff which rose forty feet out of the water. I turned off the motor and we coasted along parallel to the cliff about seventy feet away. I began to play my Japanese shakuhatchi wooden flute. Echoes of the haunting notes came back from the cliff: my very favorite places to play the flute. It was surreal. I played for thirty minutes, until I was out of breath.

Timberjack was drifting on the slight current, toward the far end of the cliff. We were only ten feet away from the rocks. I could not see the bottom of the bay. Now that we were closer, what had appeared to be the edge of the forest growing up to the rock could be seen more clearly. The trees at the end of the cliff were on a separate peninsula which extended beyond the rock wall. Through the fog I could see that there was a narrow channel between the trees and rock, and we were being carried by the water into the passage.

Tuggy, still sitting on the bow, turned slowly around, his big yellow eyes wide open, and gave a soft, meow. "Right," I quietly said. "This is cool, we'll see where this goes, eh?" Mr. Cat meowed again, then faced forward. The guard hairs on the back of his neck were standing up. I, too, felt as if something special, maybe magical, was going on. Instead of starting the motor, I paddled. There was no rush and the current was still taking us.

Soon the cliff ended in a thickly wooded hillside. The branches from the cedar trees on both sides extended far over the water, leaving about eight feet between them. The four foot wide canoe was passing through a snug fit of boughs on either side, with green water below and gray fog above. I still could see no bottom. If we had not drifted in so close to the cliff, the passage would not have been visible. I thought few people must have ever been there, and wondered where the channel led.

The narrow waterway wound into the woods for several hundred feet before opening to a circular bay about three hundred feet across, which was completely surrounded by cedar trees. The land around the bay was bowl shaped, the trees covering all the slopes. It was less foggy, but the tops of the cedars were still cloud hidden. We slowly drifted into the bay. I used a twelve foot long boat hook to see if it would reach the bottom, it did not. What a protected spot! *Uwila* could easily and snugly anchor in here.

I paddled *Timberjack* across the bay looking at the trees, curious if there was an outlet which was not obviously visible. There was! The lowest few branches of the two largest cedars had been slightly trimmed by someone to allow entrance to an equally narrow channel as the one that led us into the bay. Tuggy turned around again, and meowed louder. More of his hairs were upright, but he maintained his bow watch. I felt goose bumps as both current and paddle took us into an enchanted place.

The cedars on shore were large widely spaced old growth trees. Their branches met twenty feet above us. They were all that could be seen when I looked up. This passage was more shallow, I could see shells on a sandy bottom six to eight feet down. It was shorter, too. After one hundred feet or so, it opened into another round bay. It was smaller by half than the first bay, and ten feet deep in the center. Cedar trees also lined the shore.

Beach Mandala, Olympic National Park

The bay was one of the most tranquil places I have ever been. Tuggy also felt more relaxed, his guard hairs had settled down. I played the flute slowly again, and listened after a few notes for their echo. My goose bumps returned immediately, and Tuggy's hairs stood up again. The music that came back as an echo were not my flute's notes!!! I played another tune, and once more what was echoed did not quite match! Then, gentle, happy laughter followed the other flute playing. The sounds seemed to circle us in the bay.

I looked with more care at the shore and saw an indentation among the cedar trees. *Timberjack* moved slowly as I paddled. I noticed a ravine leading out of the bay, twisting on its course. Once again, the trees on the hills blended with those on the shore of the bay so well it was easy to miss. The sides of the ravine steepened as we followed the channel away from the bay. After a few bends, the passage opened into another large pool. What was in front of us was the most amazing home site I have ever seen. I stopped paddling and stared as we drifted towards it.

Two huge cedar logs, eight feet in diameter about fifteen feet apart, had been set from one side of the ravine to the other, a distance of at least seventy feet. The lower sides of the logs were several feet above where the highest tides would reach. The butts of the logs rested in rocks allowing water to quickly drain away so the wood did not rot. Thick, split cedar planking made a deck across the logs, overhanging them by several feet on both sides.

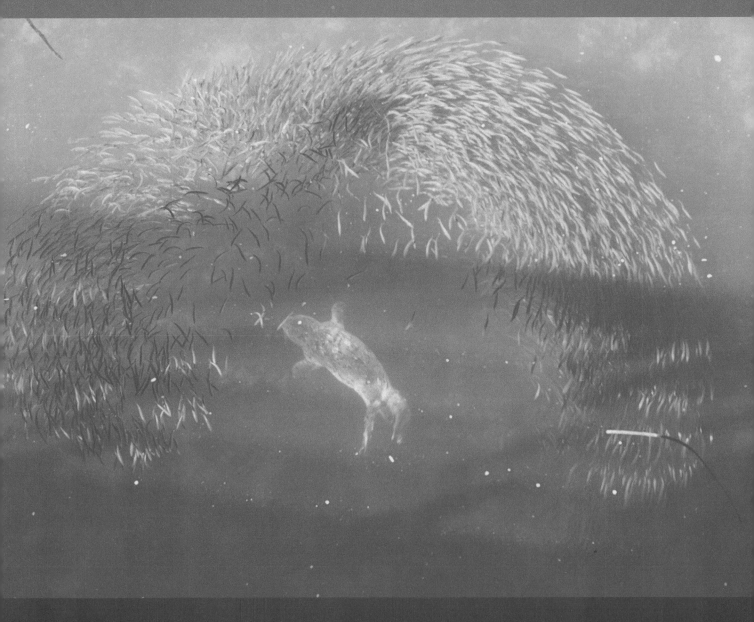

Seal and Fish - Taken from a pier, the shadows of the railing and the person next to me can be seen on the water's surface. This is a young harbor seal, in slow motion - not a feeding frenzy - carefully selecting which particular fish it will chase, and catch every time. Like most predators, it was probably choosing a fish which showed some previous injury or weakness.

In the middle was a cedar sided and roofed cabin! It was about twenty five by thirty five feet, with curtained windows and a door at each end. Several cords of firewood were stacked under eaves by the doors. Wood smoke slowly rose from a stone chimney.

Sitting in a chair on the deck was a Native American woman. Her long dark hair fell into her lap. She was wearing a deerskin skirt, a white blouse and a sheep skin vest, fur in. Her round face and dark, twinkling eyes showed great joy. She was smiling broadly and holding a wooden flute in her lap. I smiled back at her. "I am very glad you found your way in here," she said in a lyrical voice. "It is good to have a visitor now and then. Your flute playing sounded nice. It was fun to tease you with my false echo!" she laughed. I had no notion at all of her age; she could have been thirty five years old, she could have been seventy five.

The woman slowly nodded at me, then her eyes moved to look at Tuggy. Mr. Cat had been standing very still while we floated closer to the logs supporting the cabin. He focused on the woman when she was talking. Now that her attention was directed to him, Tuggy seemed to be quivering with alert tenseness. "I am happy to see this cat with you, he looks at home on the bow of your log canoe. He might have helped to find the way in here, he has that look. Your cat may be small, some of them are, but from what I know of Tuggy, he is of the special ones... let's see..." Her words made little sense to me. What happened next made even less.

The woman gave a quick series of multi-note whistles, one of which were the same notes I used to call Tuggy. Immediately on hearing her whistles, Mr. Cat launched himself through the air from the bow of *Timberjack* to the nearest cedar log! Tuggy landed on the vertical side of the log with the claws of all four feet digging in, then climbed up onto the deck through a hole in one of the planks. He ran, with his tail straight up in the air, to the chair where the woman sat, and jumped into her lap. I could hear him purring while she petted him.

I did not understand what I just witnessed, and my face must have shown it. "Why don't you tie up your canoe, and we'll have a nice visit. There are some things you should know about this cat you are spending time with," the woman said gently. I paddled *Timberjack* over, and did as she suggested.

Once on the deck, I looked back out the way we had come in. The fog was lifting, and shafts of sunlight were making wonderful patterns on the trees and water. On the opposite side of the deck was another fantastic sight: a stone and earthen dam had been built across the ravine, making a holding tank - aquarium for sea food. Many salmon were swimming in the pool feeding on schools of small fish. Large crabs foraged on the bottom, and beds of clams, oysters, and scallops were arranged around the edges in shallow areas. On one shore, now in the sunshine, was a very large rock outcrop.

A cedar dug-out canoe, twenty feet long, was hanging from natural grown knees attached to the huge cedar log. All the wood, the logs, plank deck, and cabin, were very dark, as though well oiled. What an amazing place to live and visit!

When I turned to the woman at last, she was just coming out of the cabin with two cups of tea, Tuggy at her heels like a puppy. She moved with the smooth grace and power of an athlete, a ballerina, a gymnast. We sat and drank the tea in silence, watching the sun beams become wider as the fog burned away. The water below was still, as was the cedar forest around us. Total calmness, contentment, and peace of mind were strong within me.

Tuggy had curled up in the woman's lap, and his loud purrs were the only sounds to be heard. The woman took our tea cups into the cabin, and came back to the deck. After sitting down again she smiled, petted Mr. Cat, and began speaking in that lyrical style which was so pleasing to listen to.

"I am called, 'Woman Who Lives Above The Water.' My People have lived in this spot forever, These logs were set here, and the cabin was built about seven hundred years ago. Seal and fish oil, mixed with fir pitch have preserved the wood." She spoke matter of factly, then paused for me to consider, and to let her words sink in before continuing. Seven hundred years was quite a while before Europeans found their way to this hemisphere.

Douglas Fir Tree

I looked at the planking and cabin more closely. The cedar deck was fastened to the logs with round pegs, wedges driven into their center. The planks were worn smooth, perhaps they were that old. Everything was very clean and obviously well cared for.

'Woman Who Lives Above The Water' continued. "About four hundred years ago, a ship from China was dismasted in a storm and drifted across the ocean. It came ashore near what is now called Gray's Harbor. Our People on the coast rescued and cared for those who still lived, about a dozen men, and salvaged what they could from the ship.

"The crewmen of the ship were very fortunate that their cargo was rice, so they did not starve! Also on board, probably to kill rats, were several dozen large, all gray cats with yellow eyes; both females and males. Our People knew bob cats and cougars, but had never seen domesticated cats. They were very taken by these animals which weighed twenty to thirty pounds. These gray cats were bred and traded around the area. Many found their way to our islands. They were very smart, and were trained in some ways. Let me show you."

She stood up, holding Tuggy with both arms, and whistled an even longer and louder series of multi notes. Mr. Cat's eyes got huge when he heard her whistle, and when he saw what happened next. Over the rock outcrop by the dammed up water came running about twenty large gray cats! They stood there looking towards the woman, as if expecting a command.

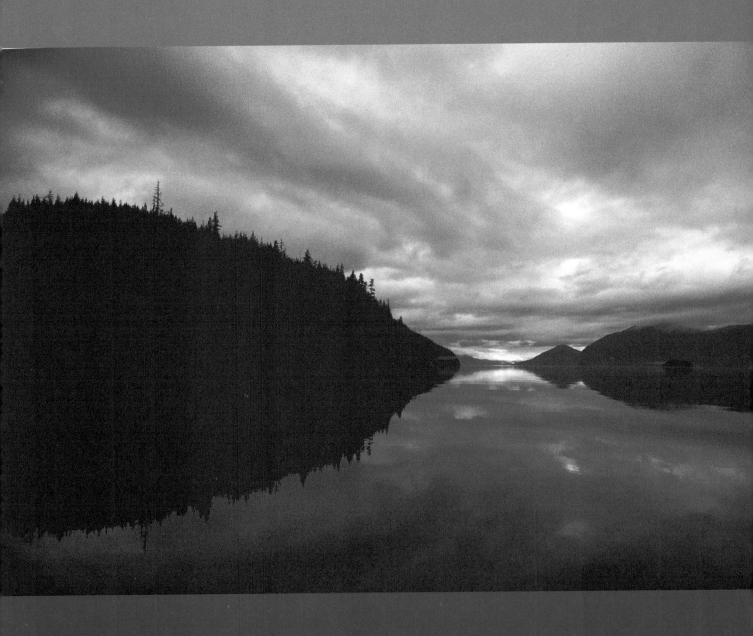

Johnstone Strait, B.C.

She whistled several short times, and the six largest cats, dove into the pool of water!!! With teamwork swimming, they cornered and caught several salmon by hooking their claws into the fish, then killing them by biting through their backbone behind the head. They brought the salmon onto the deck by the woman. She petted each wet cat while still holding Tuggy.

Scratching Mr. Cat under his chin, she set him down by these big dripping cats. "Say hello to your cousin," she said to them. The cats sniffed, smelled, and rubbed against each other for several minutes, then began washing themselves. Tuggy sat with them, purring.

At another whistle, all the rest of the cats ran onto the deck, where more inspecting and greetings went on. The woman quickly cleaned one of the fresh-caught fish and took it into the cabin to cook on the stove. The other salmon were put in a feeding trough where the cats, including Tuggy, took their turns eating. After having their fill, the cats walked back to the big rock where they washed each other then lay down in the sun to nap for a while. Tuggy joined them.

The woman sat down again and continued her story. "These cats catch fish, crabs, and birds. In packs, they hunt raccoons and small deer. And, of course, they keep rats and mice out of our food stores. They were a very useful addition to Our People's lives. Nowadays they make good pets, especially if they can live on a boat, which only a very few have the opportunity to do. There is something in their genetics that makes them comfortable on the water, as you know well!" She laughed, and I laughed too.

Shore Crabs

"All the big, yellow-eyed cats in the Northwest come from that one Chinese ship," she continued. "When the first white sailors visited this area, they called them Puget Sound Panthers, and were glad to trade iron goods for some cats to have on their ships to eat rats.

"Through the years we have kept track of where these gray cats are, and who lives with them. We want these cats to be with the proper people. If we learn about one of them being treated with less than the care they deserve, some of Our People will call the cat away at night, and bring it here to the island where it joins our pack of Panthers." What a wonderful story! It was not difficult to believe what she said, having seen the cats in action.

The woman continued, "You and your Mr. Cat have been known to us for some time. We were very happy to hear of a gray cat who lived aboard a boat, especially a sailboat. One thing we have heard about must be seen, though. Please call Tuggy." I looked at the rock covered with large gray cats. One of them must be Tuggy, but they all seemed identical, except that some were larger than others. Tuggy, I knew, was one of the smaller cats. I whistled for him, and all the cats stood up! What a sight. I whistled again, and there he was, moving among all the others. Tuggy rubbed noses with several of the cats on his way to the deck.

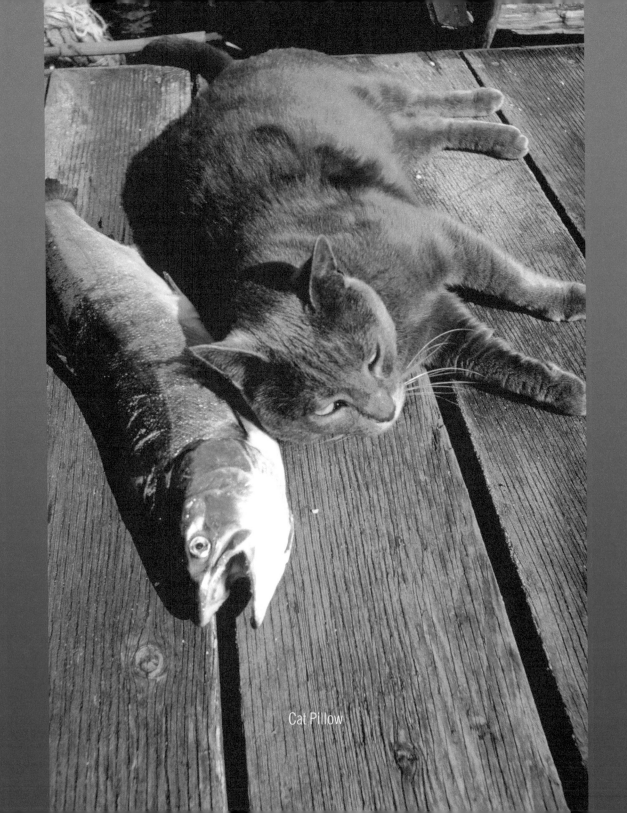
Cat Pillow

I petted Mr. Cat, then the woman petted him. She reached into a pocket in her skirt, and slowly pulled out a dozen clothes pins! Tuggy looked at both of us and seemed to roll his yellow eyes as if to say, "Oh no, not her too!" But he sat there patiently while the woman placed her clothes pins on his fur, petting him and laughing. I laughed with her. "We did not really think one of the gray cats would allow such treatment," she said in wonder. "You have done something very special in training this one, unless it is from within the cat."

"I believe it is Tuggy," I told her. "He likes it when people are happy, and when he is wearing clothes pins we laugh. His Buddha nature does not mind if he seems to appear silly or unusual." The woman nodded in agreement, and we both laughed louder. I don't know what the other cats thought, and as usual Tuggy accepted being the source of such humor.

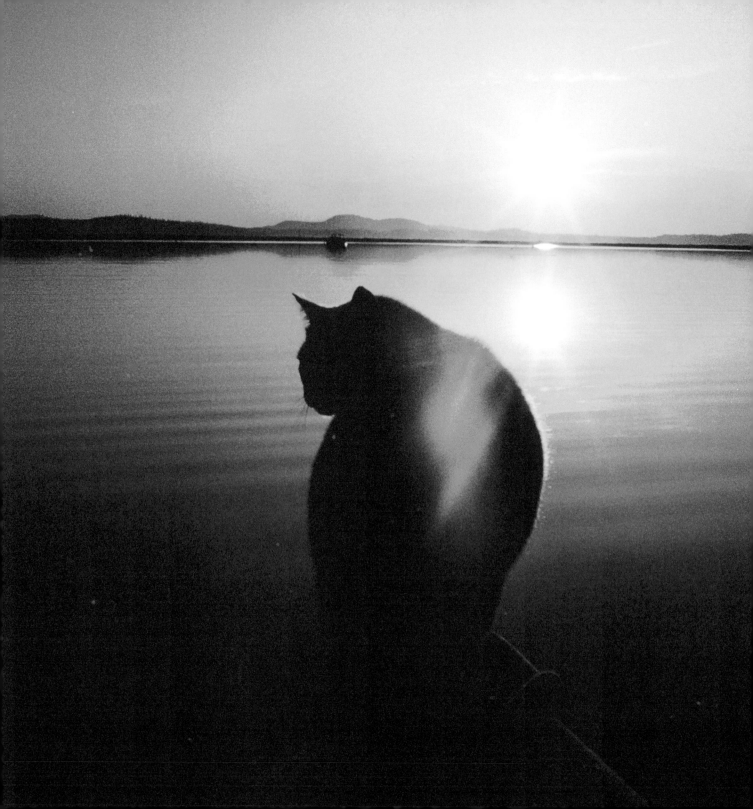

We ate the salmon she cooked, and several fresh vegetables, then it was time to find our way back to *Uwila*. "Thank you for taking the time, and making the time, to visit this area; and, for finding your way to my cabin. It was a great pleasure to meet you and Tuggy at last. I will tell the others who know about these cats that the clothes pin story is true!" she laughed again. "Visit again anytime, and give my warmest regards to the 'Man Who Is Much More Than He Looks,' when you see him again." I thought for a moment, then realized she was speaking of John Erickson. "I will be glad to pass on your greetings. Thank you for telling me about Tuggy's heritage and the Puget Sound Panther."

I got into *Timberjack*, and Tuggy jumped aboard as I was untying the lines. When I stopped paddling and turned to wave good-bye, the woman waved back and said, "I do hope you write the book about Tuggy's adventures! Many people will enjoy reading about him, and seeing your photographs."

It was almost sunset when Tuggy and I returned to *Uwila*. After tying *Timberjack* alongside and coming aboard, I lit the kerosene lamps and began dinner. Tuggy stayed in the canoe for a long time before jumping onto the sailboat. "Well, Mr. Cat, that was a most educational day. Tomorrow, perhaps, we will go the other direction and see what finds us, eh?" Tuggy purred loudly.

The End

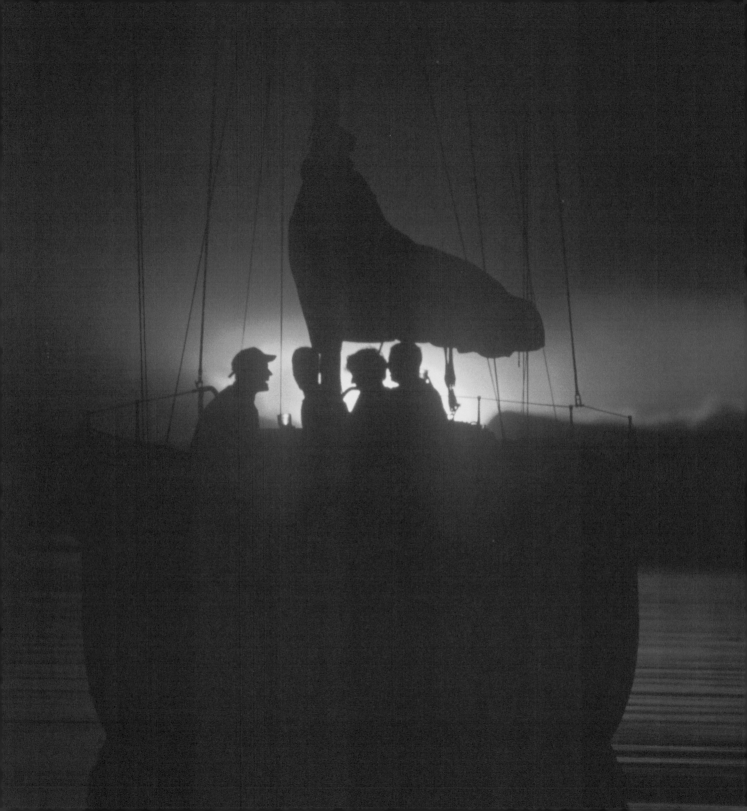

Thank You Very Much!

Great appreciation and gratitude to W. Bruce Conway who not only used his considerable graphic design skills and computer knowledge to make this book look the way it does, but also patiently waited more than twenty years for me to be ready to make the book real.

To Wendy Seaa Brown for enthusiastic support and
comments from her view in the Peanut Gallery.

To the Advanced Copy Readers whose input made the book better:
Linda and Dave Ber, and Annette Fromm.

To Alice Acheson who took the time to share guidance and information
from her lifetime in the world of books.

To Denver Digital Imaging for scanning prints and slides.

To Cecil for scanning slides and being there.

To Arne and John Bentzen for building *Uwila*. One of the greatest honors
I have had is to have these humorous and bright brothers regularly in my life.
"It's not all bad," Arne would say. I feel is was mostly good.

To Mom and Dad (Mollie & Marvin) for unconditionally loving their three children
whatever wild, crazy and unusual things we became involved with; and for teaching us
very well that, "We are not lost. . . We are having an ADVENTURE!"

And to you for making the time, and taking the time, to read this book.

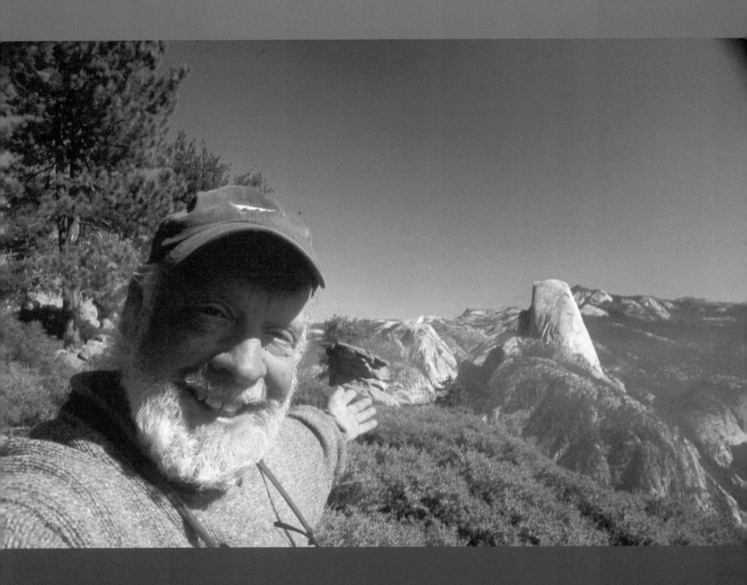

The author in 2017 in Yosemite National Park

Peter Fromm

- Began taking pictures in 1960, professionally since 1970; completing numerous assignments, teaching photo classes, winning contests, and having photos and writing widely published in books and magazines.

- Earned a Bachelor of Fine Arts Degree in Photography at Ohio University in 1971.

- Directed Earth Day activities in 1970 at Ohio University

- Was awarded a Master of Science Degree in an Interdisciplinary Studies combination of: Audio - Visual Communication, Environmental Education and Outdoor Recreation at the University of Oregon in 1974.

- Created two volumes of *Whale Tales - Human Interactions With Whales*, and an accompanying educational presentation sharing people's stories about their encounters with Cetaceans, the biology of these animals, and examples of the changing relationship between whales and people.

- Was a Speaker in Washington Humanities Inquiring Mind Program with *Whale Tales, Visions of a Water Rat - Boats and Boating in the Pacific Northwest, Wooden Boats - Spirits on the Water*, and *The History of Maritime Transportation*.

- Is a life-long outdoorsman: exploring caves, climbing mountains and rocks, rafting white water rivers, backpacking, racing and touring on bicycles, and lots of boats, boats, boats.

- Held a U.S. Coast Guard Masters' License for thirty-six years.

"The camera is a tool to record, in two dimensions, what we see in this three dimension reality we share. In 1968 I fell in love with the Nikkormat camera made by Nikon - a totally manual, 35mm, single lens reflex, with a through the lens light meter. It is still the camera I use today, with Fuji Provia slide film, to make honest images of our world."

Crow and Grape

Naturalist Henry Beston:

We need another and wiser concept of animals.
In a world older and more simple than ours they move finished and complete,
gifted with extensions of the senses we have lost or never attained,
living by voices we shall never hear. They are not bretheren, they are not
underlings; they are other nations, caught with ourselves in the net of life
and time, fellow prisoners of the splendor and travail of the Earth.

Ken Balcolm:

Is one of the founders of The Whale Museum. He also created and directs the
Center for Whale Research. Ken kindly once reminded me: "Nature... Bats... Last."

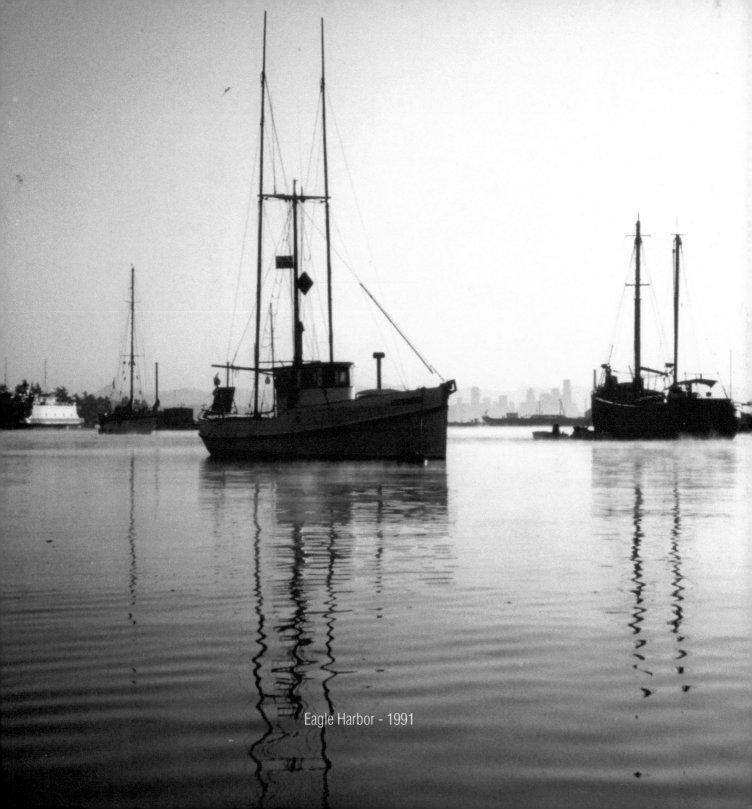
Eagle Harbor - 1991

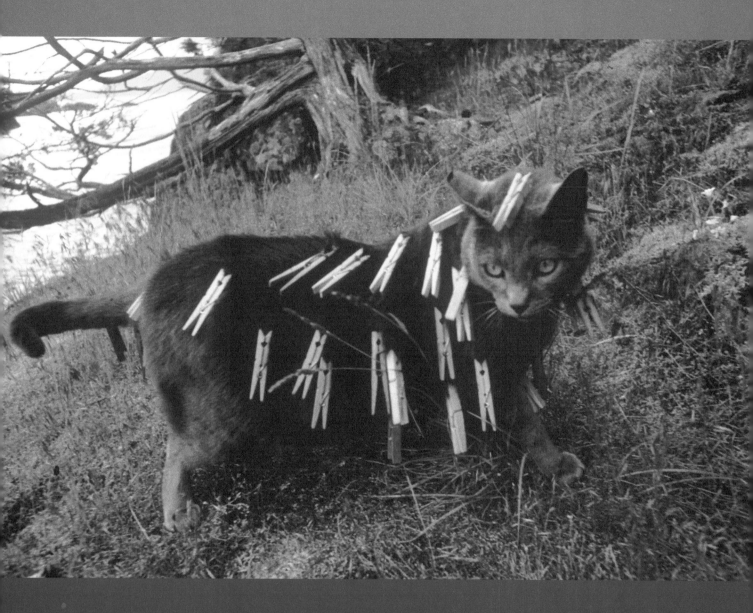

See page 83

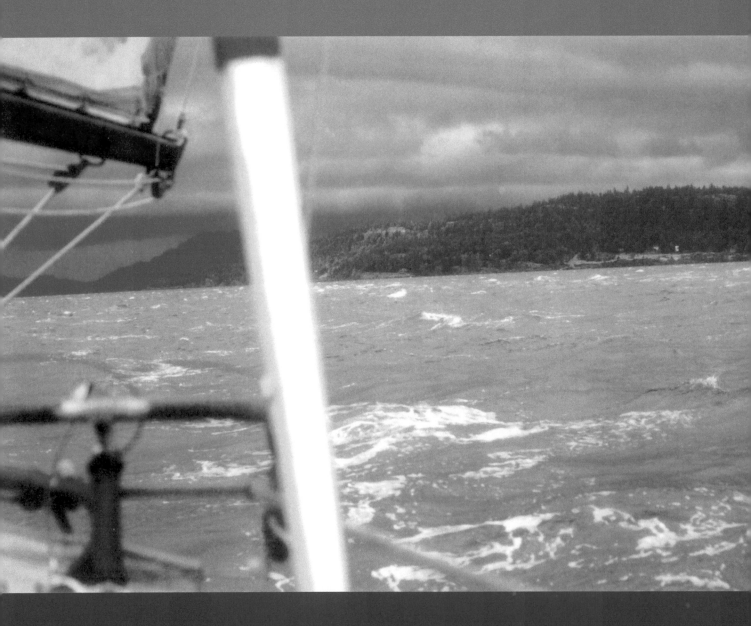

Heavy Weather Sailing

CPSIA information can be obtained
at www.ICGtesting.com
Printed in the USA
LVHW071852120422
716021LV00002B/73